HASHTAG
AUTHENTIC

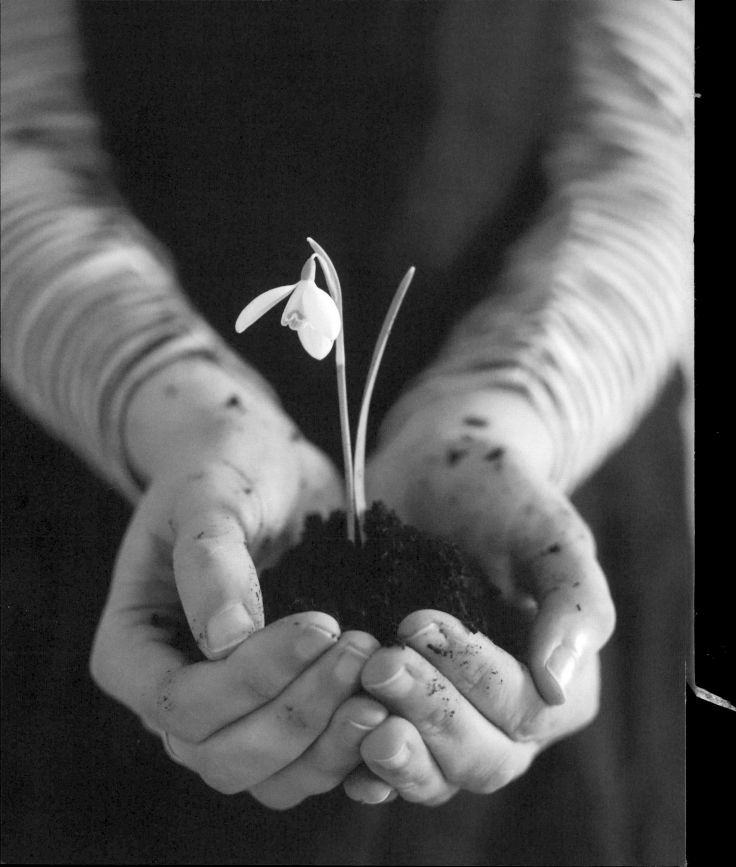

HASHTAG AUTHENTIC

Finding creativity and building a community
on Instagram and beyond

SARA TASKER
@me_and_orla

WHITE LION
PUBLISHING

Brimming with creative inspiration, how-to projects, and useful information to enrich your everyday life, Quarto Knows is a favourite destination for those pursuing their interests and passions. Visit our site and dig deeper with our books into your area of interest: Quarto Creates, Quarto Cooks, Quarto Homes, Quarto Lives, Quarto Drives, Quarto Explores, Quarto Gifts, or Quarto Kids.

First published in 2019 by White Lion Publishing,
an imprint of The Quarto Group.
The Old Brewery, 6 Blundell Street
London N7 9BH
United Kingdom
T (0)20 7700 6700
www.QuartoKnows.com

A catalogue record for this book is available from the British Library.

ISBN 978-1-911127-61-1

10 9 8 7 6 5 4 3 2 1

Design by Isabel Eeles
Edited by Sian Parkhouse

Printed in China

CONTENTS

INTRODUCTION

By the conventional rulebook, I should never have found success. Small, socially awkward and devoid of any real self-belief, I made none of the life choices that could facilitate my dreams coming true. I thought I might make a good photographer, but didn't dare choose to study it at university. I love to write and considered journalism, but there was no way I could move to London to await a break that would probably never arrive.

Instead I built a quiet, simple life for myself and squashed those dreams down into hobbies that never asked me to try. I told myself all the bigger dreams were for other types of people: those from wealthier families, with better health, mindsets and opportunities. And then Instagram changed my world.

That sounds ridiculous, I know – to give so much credit to a free app we all have on our phones. And yet it is utterly true: starting my account, beginning to take photos and share tiny fragments of my thoughts was the catalyst to everything unfolding for me; the tightly scrunched paper ball of my life being spread out and opened, full of uncharted territory like a long-forgotten map.

I was on maternity leave from my National Health Service job, learning the ropes of being a mother and feeling utterly, hopelessly lost. I hated being in our inner-city home, looking out onto concrete and other people's walls. I missed my job, my patients, my sense of usefulness. I missed my identity outside of this new role of motherhood that, like my post-partum wardrobe, just didn't seem to fit how I'd imagined. I sat at home under a sleeping newborn and wondered how I would tell her about all the talents and skills that I'd secretly possessed, but never thought to put to use.

Trapped in this bubble, whole days fuzzing by, I turned to my phone for some solace and company. And that's when I discovered Instagram.

Here was a place where my creativity could exist. Here was a space where I could connect with others – other parents and mothers, yes – but also makers and writers and artists and coaches. It was a place where I could reclaim a wider sense of identity; where I could put all my years of nerdy Internet sharing and connecting on forums to a next-generation use. It felt like a place where I could be entirely and safely myself; something I had never – and still haven't, if I'm honest – managed to fully discover in the realm of 'real life'.

I called my account Me & Orla – myself and my daughter – because in those long stretches

of empty daytime, that's all that it felt like there was. I began to share the small, inconsequential moments of my days – the ripe pears on the windowsill, the way the sunlight streamed through the curtains in the afternoon, the slice of cake I walked two miles with her to eat. Too tired to lug around my old DSLR, I decided to shoot a photo each day using only my iPhone, and so began my long-term love affair with those incidental phone cameras we carry with us wherever we go. I set myself a challenge on 1 January that year: I would try to post daily and find 1,000 followers by the end of the year. Within a month I'd exceeded that target, and by April I'd been featured by Instagram and was approaching my first 40k.

From there things continued to bloom: a bigger audience, a well-read blog, lucrative influencer work, press coverage, new friends, trips away and exciting events.

I was able to quit my job and move my little family out to the countryside, to a house that was home, where the windows look out onto green hills and sky. And I found my real passion – the thing that got my heart pumping fast: talking about the how of it all. Sharing with anyone who wanted to listen what I knew and had learned about photography, social media, Instagram and beyond. How to use it, as I had, to build something more, in this digital landscape that didn't follow the old rules.

I began to mentor, and then to teach online courses and classes about social media. Gradually that grew into the multiple six-figure business that employs both me and my husband today, with enough time and space for spontaneous summer picnics with Orla, or a 'what the hell' road trip when my schedule allows.

My free podcast, which shares its name with this book, has allowed me to connect with thousands of other like-minded souls, and my speaking engagements have taken me on more far-flung adventures than my old self had amassed in her whole thirty years.

I've appeared in my favourite magazines – *Marie Claire*, *Cosmopolitan*, *Stylist* and more – chatted on BBC Radio and – in what I think we can all agree is the ultimate achievement in life – exchanged a string of DMs with my teenage celebrity crush.

But most significantly of all, I'm living my life as myself. Seen and heard, messy parts and all – and learning the kind of valuable lessons that I hope will help my daughter escape all the traps that I'd put myself in.

Tuning into my creativity and finding a community that sees the world like I do has been transformational. And when I stopped to look back and took in all it had made possible, I really only had one question that I couldn't find an answer to. 'Why did nobody tell me this was possible?' My hope is that this book will tell you what nobody has before. That it's possible, entirely doable, for you, right now, exactly as you are. Not you ten pounds skinnier, or you in another degree's time. Whatever you have, whatever has brought you to this point, it's really all that you need to begin to follow your heart.

People will tell you it's silly. There will be folk in your life who simply won't understand. That's ok; it doesn't matter. Do it anyway, and trust that your right people – including me – will be cheering you on.

The Internet is a huge, diverse and colourful place. Dive in, share your world, and come see what is waiting for you.

STORYTELLING

OUR VISUAL CULTURE

My Grandad took pictures. Hundreds of them, each one a tiny rectangular labour of love. Light metered, settings carefully chosen, he would capture the moment and wind on the film; walk down to the camera shop days or weeks later to get them developed, and then write on the back in his perfect, sloping hand, the place, occasion, and date.

Both he and my Grandma are gone now, but these pictures remain. I found so many as we cleared out their home – an entire treasure-trove of forgotten memories and love. Pictures of them smiling at familiar Venice landmarks. My Grandad, a heartbreaking twenty-year-old soldier with dreamboat hair, perched on the hot steps of the Pyramids in Egypt. Me and my siblings with toys, with friends, with Christmas trees, with missing teeth. In school uniform, in tears, in homemade Halloween masks.

An archive of our very own, and the most wonderful, magical gift.

Things are different now. Nobody prints photos any more, and there's no need to write the date and place. Yet almost every one of us is building our own little archive, day by day, using the camera we carry around in our pocket. Smartphone technology and digital photography have removed the problems of expense and accessibility that our grandparents faced, and in doing so, have taken away some of our intentionality, too.

When every shot costs you money and time to develop, you give it some thought. We are blessed not to live with this boundary – I'm sure I and countless other digital photographers would never have discovered their gift with those barriers still in place. We can play, experiment, take fifty shots and just keep one. It's a wonderful, liberating thing.

But the downside is, we often give it less thought. We don't work for that right angle quite as much, we don't scrutinise with our photographer's eye. What does it matter, after all? We're just going to stick it on Facebook for a day, then forget it exists, right?

I believe it does matter. In a digital age, the place for pictures in our lives has changed, but that doesn't mean they have lost their significance. Being mindful, artful and creative with our cameras can forge powerful connections – with your friends and family, with the wider community, and with yourself as well.

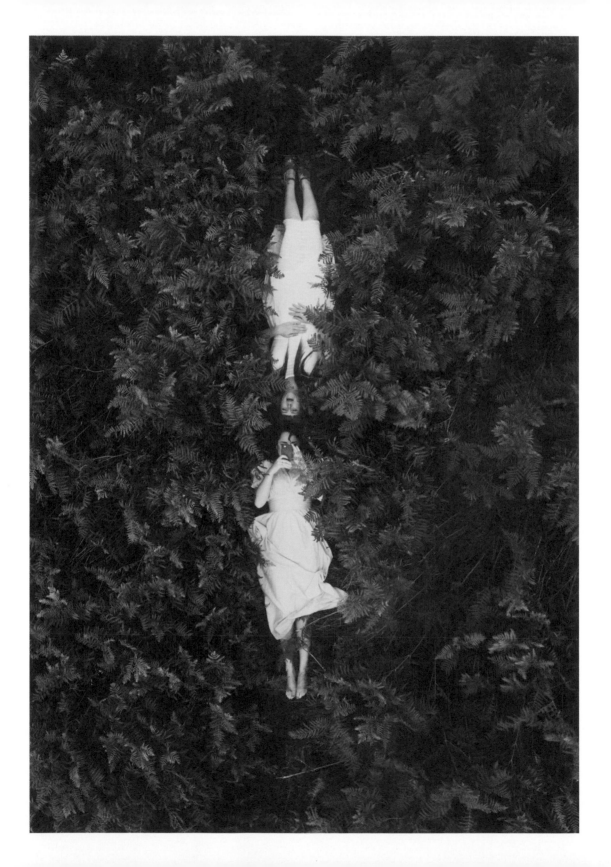

THE DEMOCRACY OF DIGITAL PHOTOGRAPHY

We're so fortunate to live in an ever-evolving age of photographic technology. Once just the preserve of those with a decent disposable income, cameras are now almost ubiquitous in the western world; always in our handbag or pocket as part of our smartphone or tablet.

Gone are the costs of rolls of film and the lag time of developing, and all the expensive mistakes of that learning curve. Now, any one of us can take 100 photographs at no extra cost – then delete them all, and take 200 more if we want! The barriers to photography have come crashing down, and now anyone and everyone can get involved.

It's an exciting time, with increasingly diverse voices, stories and creations flooding our senses, and the evolution of platforms like Instagram has made it easier than ever for this work to be shared.

And we all have a story to tell. In human history, there have been too few voices with little diversity. Women, people of colour, people with disabilities, the LGBTQ community and a great many others have found themselves rendered invisible through a lack of representation in art and books and publishing. The internet, and platforms like Instagram, gives everyone the chance to own their voice for the first time in human history. I believe this is a big part of the reason why the mainstream media will so often deride bloggers and YouTubers and Instagram stars. We're not playing by the old rule book and we're not telling the stories that have always been told.

Still, it's easy to judge ourselves by these old standards. Isn't Instagram oversaturated now? How is me sharing my morning coffee going

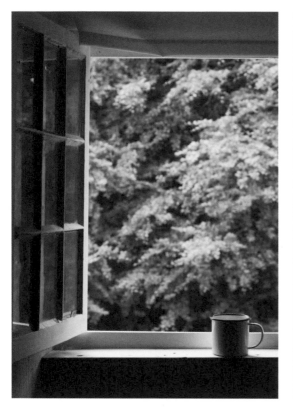
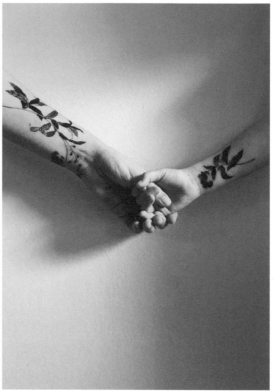

to change the world? Well, maybe it won't, but that doesn't mean it has no value.

Perhaps your habit of making time for your coffee each day gives a burnt-out mother permission to do the same for herself. Perhaps the caption you add, mentioning how you switched from plastic coffee pods to a biodegradable line, prompts a handful of others to do the same, and then take further steps to go plastic-free. Maybe the cafe you tagged in the photograph gains a new local customer thanks to you, and becomes a little more profitable as a result. Connection, communication and community are the underrated secret weapons of

social media. Quiet and gentle, they nevertheless have the power to slowly shape our world.

Where would we be if our favourite authors, musicians, teachers and role models had thought their voices were not important enough to be heard? How many times have you read an article or a blog post by someone who is similar to you, and felt vindicated or heard or enlightened as a result?

Instagram isn't oversaturated – it's not saturated enough. We need more people, more diversity, more perspectives. We need a cacophony of voices so that 100 years from now, the history books (or holo books, or whatever we have then) will have no choice but to mention us, and have room for us all.

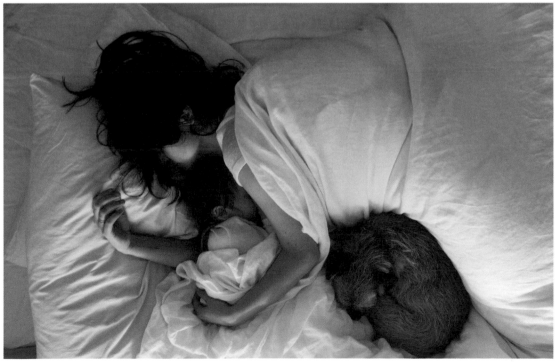

START WITH WHAT YOU HAVE

In any new hobby or art, we're always faced with a rush of self doubt – will I be any good at this? Will anybody like what I create? Will I be rejected by the people I'm trying to connect with? Appeasing that little voice is tricky at the best of times, but can be made even more challenging if we have to take a big leap financially as well as emotionally to embrace our new craft.

Or, perhaps affordability isn't a barrier for you, and so instead you tend to overbuy for your hobbies. You'll know if this applies to you – there's probably scores of abandoned craft projects stashed away in your home, with all the best, top-of-the-range equipment that you bought and barely used once you began. Buying stuff, however great or flashy or seemingly vital, is no replacement for actually doing the work. Learn to

ignore the little voice that might be saying, 'I can't possibly start until I have X, Y and Z!'

For all these reasons and more, I urge you: start now, with whatever you have. Smartphone, basic point-and-shoot camera or top of the range DSLR – they're all just as valid, and just as capable of creating beautiful, powerful imagery.

As photography becomes increasingly accessible and automated, it's less and less about who has the best kit or the fanciest techniques anyway. Instead, the focus has swung back to composition – what is the story? What can you make us feel? Where can you take us with your photographs? In a world of instant sharing, narrative, vision and composition are the modern photographer's most important tools. They come with practice and patience, and they are completely and liberatingly, free.

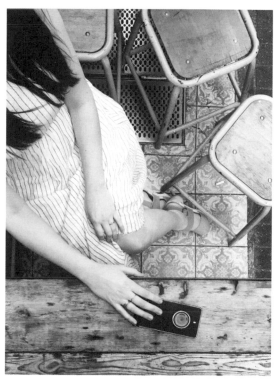

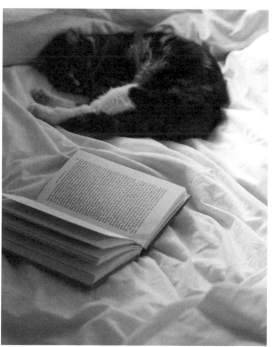

FINDING INSPIRATION IN
YOUR EVERYDAY LIFE

We tend to think of photography as a 'special occasion' thing. Birthdays, trips away, a day at the beach, a first day at school. In these moments we are motivated to look through a lens and capture something that feels precious and transitory – to preserve forever the happy memories we're about to make.

Instagram and the little smartphone camera in our pocket allows us to document life more much frequently than this. Often, that can feel overwhelming at first – what should I shoot? I've got nothing worth photographing!

Later in this chapter I'll share some tips and tricks for gathering subject ideas, but for the most part, my answer is really no different from the list above. Shoot the special things – the stuff that is precious. Take pictures of the things and the occasions that you treasure the most. Anything and everything that you never want to forget.

What changes, when we shift our mindset to taking more photographs on a more regular basis is how deeply we dig into what 'special' really is.

The first day of school is a milestone, of course – but it is built from a thousand other tiny milestones along the way. These moments don't show in the typical photo – child standing against a blank wall, gappy smile, too-big uniform freshly pressed. Learning to tie shoelaces. The messy affair of breakfast. The thrill of a new pencil case packed with carefully chosen pens. Writing their name for the first time in scrawling, messy print. A little mittened hand slipped nervously into yours and foggy breath clouding the air on an early winter morning.

Photographing our everyday lives allows us to zoom in on the details and think about the small things that hold big meaning for us. With practice, it becomes a daily meditation on gratitude – a visual record of the beauty of ordinary everyday life.

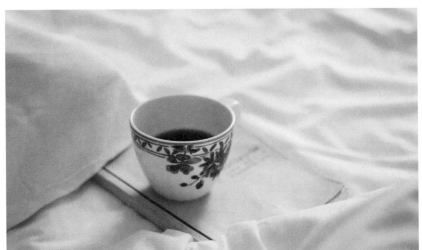

A VISUAL TIME CAPSULE

One cold, drizzly day while browsing a flea market that had sprung up in a nearby village, I happened across an old bowl at an antiques stall. It was white china with a blue floral pattern and a teddy bear drawn in the bottom. And instantly, standing there with cold cheeks and a fidgeting child at my side, I was transported back to my own childhood, when I myself was just two or three. I didn't even consciously remember this bowl – I would have drawn a blank had you described it to me, or ever asked me if I had owned one. But when it was before me, those early neural pathways in my brain sprang to life again, and its pattern was achingly, magically familiar.

It's the most curious sensation, and one that most of us have experienced at some point. Discover an artifact from your past and you can be whisked back into memories you had no idea you still held. The colours, print or texture in a mundane item can be so comfortingly familiar that for a second it is like time travel – the years slipping back to when this inconsequential thing was a part of your small and certain world.

Photographs have this ability, too. And what I found, when digging back through my Grandad's archive, was that it was seldom the obvious and posed photographs that brought this magic to life. There were so many of these – my sister and I in Halloween costumes or our best party dresses against a living room curtain or wall. Portraits taken for the purpose of finishing a roll of film or capturing a childhood milestone. In fact, nearly all of my Grandad's photographs are portraits of one kind or another – holiday snaps at landmarks, groups of smiling faces at family gatherings. They're precious in all kinds of ways, but it's the incidentals that bring about that visceral, elusive sensation of rewinding the clock.

The pattern of a carpet, a toy just in shot at the side of a frame. Maybe it's a pair of shoes that I'm wearing that I can suddenly recall made a clip-clopping noise when I ran across pavements, and how grown up and special that made me feel. Maybe it's the sideways glance of a sibling that belies the obliging smiles we paste on for the flash.

In every case, it's the incidentals, the petty details of everyday life, that hold the most magic for me. We tend to remember the big red letter days, more or less — they are memories we revisit as we grow, stories we tell to new friends or lovers as the years go by. Seldom do we stop to recall the pattern on our grandmother's carpet, or the smell of the tomatoes we grew one long heatwave summer from seed.

These are the fabric of our stories, though. Train your mind and your eyes to look for the precious in your everyday life. What do you want to remember, twenty years from now? What would go into a time capsule of your daily life, today?

And then, reach for your camera, or your smartphone, or whatever's around. The plan is not to be perfect. It's not to keep every photo for ever. Instead, it's an experiment – in gratitude, in noticing, in being present. And it's the beginning of our Instagram journey together.

Magic in the mundane

Grab a notebook and pen (or open up your smartphone notes) and begin to draft a list. What are your favourite parts of the day? Forget for a moment the monotony and the parts you dislike, and focus in on the tiny things that bring you a rush of joy in your gut.

For example, my list would look something like:

- *The little drawings my daughter doodles in the steam on the bathroom windows*
- *The hiss of the espresso maker on the AGA, brewing my first cup of the day*
- *Lighting a candle at my desk before starting work*
- *Tying my hair up in a piece of vintage ribbon*
- *The cat curling up at my feet as I type*
- *Discovering there's still cake left and eating it for lunch*
- *The afternoon light streaming through the kitchen window*
- *Spotting my daughter's muddy boots by the door*
- *A longed-for package arriving in the post*
- *Making soup with a rainbow of misshapen vegetables*
- *My daughter coming rushing home, with her hair smelling of woodsmoke, full of stories from school*
- *Turning on the fairy lights in the kitchen window as it gets dark*
- *A wilting dandelion my daughter brings back for me from the park*
- *Driving past tiny new lambs in the nearby field*
- *Sharing a glass of icy cold wine with my husband before bed*
- *My dog trying to carry a stick that is more like a tree*

Yours might look totally different – perhaps you live an urban, glossy life (in which case, please teach me your ways!). Perhaps your joy comes from your clothing, your interiors, your family or pets. Maybe you're a total foodie, and your list is 90 per cent edible.

Or maybe it's harder for you. Maybe you're living in a house you hate (I've been there!), struggling to make ends meet (been there, too), and the best part of your day is sitting down with a plate of toast and watching reruns of *Grand Designs* (yep!). That's fine. That's perfect. That is your story to tell.

Perhaps, though, you find your list is woefully short, and you're not entirely sure why. It's surprisingly common – especially for women – to push back all of our joy to a lower priority, and spend our days fulfilling other people's needs and wishes instead. If your life is lacking in these simple, joyful moments, make another list now of how you can start to add some in. Not for me, for this book, or for Instagram, but for your own sanity and quality of life. It's not selfish to want to enjoy your life a little. It's the only one you've got.

Now, look at your list. How many of these could be a photograph?

With a little creativity, I suspect they could all be translated visually. Add in a caption to bring extra context, and you've suddenly got a tiny story, a narrative of your daily life that you can capture and save. And – if you'd like to – go on and share it with the rest of the world, and maybe inspire others to try it, too.

If you decide to share your pictures of any
of these moments, use the hashtag
#hashtagauthenticbook

I'll be following the hashtag and sharing my faves on my
own social media to help cheer you on.

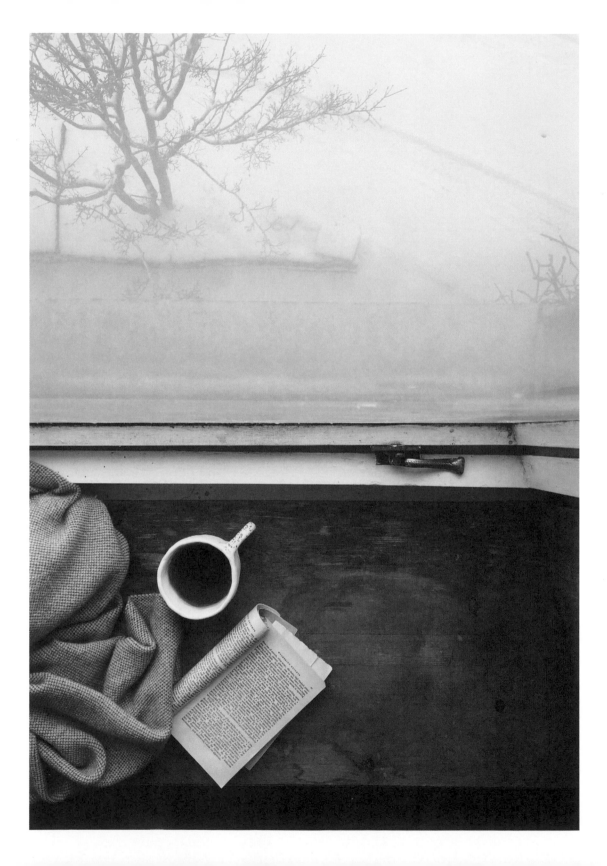

MOMENTS, NOT THINGS

Years ago, in the early days of the Internet, my friend Jo and I made a point of still sending one another 'snail mail' letters from time to time. It was an idea driven by nostalgia – an attempt to keep the handwritten word alive, and also just to give each other something nice to look forward to in the post.

One week, Jo sent me a page torn from a clothing catalogue that we both adored. In the photo, a model laughed to the camera, one hand clutching a weathered French cookbook; the other dangling a messy wooden spoon. She had one of those effortless messy updos, and was in the hallway of a house that was all wooden floors, floor-to-ceiling bookshelves and white paint.

Jo wanted the entire outfit being advertised. As we were both poor students at the time and this was financially impractical, she had set about analysing why she wanted the outfit, and tried to label her reasons with arrows and text.

I remember this: she wanted to be that kind of girl. She wanted to be able to cook from complicated recipe books, to read fluent French in a bright and beautiful home, while someone (a loving partner, perhaps) took gorgeous photographs of her laughing, looking casually, effortlessly chic.

The outfit was forgettable – literally, I remember nothing about it any more – but the image, and the story it told, was enough to transport her, and make her want to buy a tiny slice of that girl's life.

That letter changed the way I looked at everything. Suddenly I saw how a single still image could be much more than a picture – it was a story, a feeling, and, in the case of advertisements like the one Jo had sent, a seduction of sorts.

Now, we aren't all in the business of advertising, but there are two important things we can take from this. One, that images have the power to make us feel any number of things, and should be crafted and shared with compassion and responsibility. And secondly, that the best photographs to share – the ones that truly resonate with other people, online or off – do so because they tell a story.

I have a mantra I share with all of my students for this – *moments, not things*. Which is more powerful? A photograph of the beautiful new cup you just bought, sat alone on your kitchen surface under the fluorescent ceiling light – or

that new cup filled with tea, with a blanket nearby, a book, maybe a biscuit, and a sleeping cat?

Which image is more memorable, transporting, emotive and relatable? Which one tells a story and makes you feel?

When we shoot moments instead of things we capture the feelings as well as the facts. It's the difference between the kids tearing into their presents around the tree on Christmas morning and simply a photo of that year's tree, sat alone in isolation. A great moment, photographed, makes us nostalgic – in fact, it should feel that way even if we only shot it yesterday.

The funny thing about photographing moments is, sometimes they don't entirely speak for themselves. Sometimes we, as photographers, have to add in the missing elements, style the scene, and think about what it is we're trying to say. Just like the street photographer moves the empty Coke can out of the scene, or the wedding photographer cues in the confetti when she's ready for the shot,

we have to be willing to be a part of our picture, and shape reality to match our ideas. This is especially true if we plan to share our imagery on a platform such as Instagram, where a photo might first be viewed without any context among a sea of other imagery.

One handy bonus of doing this and getting hands-on with the art of visual storytelling is you become a whole lot harder to flog those forgettable outfits and other crap to. That picture my friend sent me would still make me feel if I saw it today – but now I'd look at it and know the outfit wasn't the secret to having that life. I'd be better off learning to cook from that cookbook, or taking a French class, or perfecting the perfect messy updo from tutorials online. Because the thing about feelings is, it takes more than possessions or shopping to change them. By building these moments for ourselves from the inside out, we get very good at seeing what the story is really about, and how we can make it our reality.

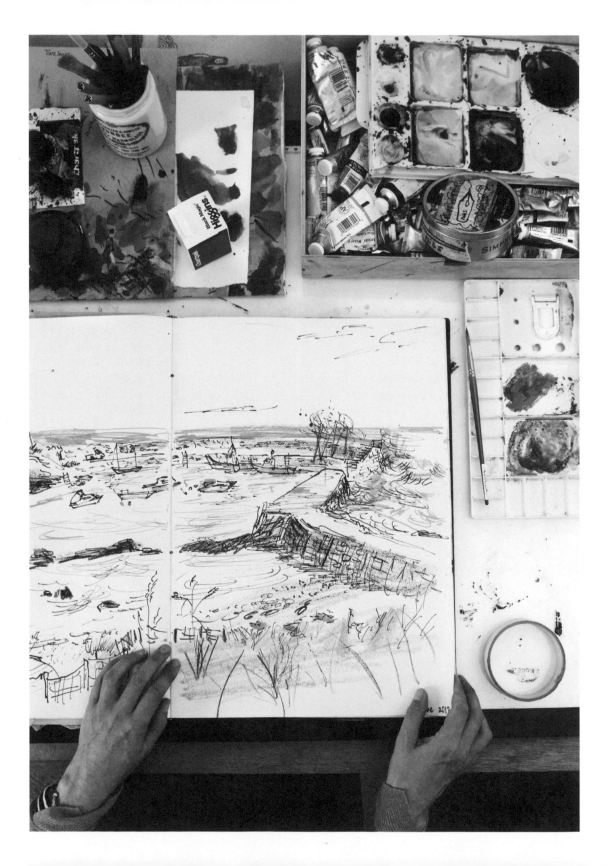

EVERY PICTURE TELLS A STORY

'*A picture speaks a thousand words*' says the old adage – except, of course, it doesn't. Words are just the packaging we put around ideas and objects in order to communicate – be it Sign Language, in writing or something spoken aloud. Pictures are the one type of communication that don't need any words at all.

This was never more clear to me than while working in special schools with children with learning disabilities. Pictures allowed us to communicate on topics that a child might never learn the words for; they could ask for the flashing pink rubber caterpillar toy, for example, just by handing me its picture from a pile.

Pictures transcend language barriers, cognitive differences and offer a different experience to everyone who sees them. A photo of the drive to my daughter's school might look grey and mundane to my eyes, but would be fresh and exotic to someone in a hot, sunny climate.

Consider this photograph of my friend, illustrator @helenstephenslion at work (*opposite*). If you were to try to put this photo into words, where would you begin?

I'd probably start by saying that it's someone's hands holding a book, a woman, by the shape and size of her hands, perhaps, and what I can see of her clothing. I'd talk about what I can see on the pages, what's there on the desk.

If I had time after that, I might dig into how the mess suggests a well-used workspace, the quality of her work, perhaps speculate as to the season based on her sweater and the light and her drawings.

All of that would take several minutes, and we'd still be missing so much of the details. The colours, the textures, the mood. A viewer of a photograph is able to access all of that information with only a split-second glance.

Of course, not every photo we take will have this level of context or complexity, but often the best images can still convey just as much story and narrative regardless. I find when a composition or shot feels a little empty or lacking, it's this narrative, or 'plot line' that I've somehow broken, or missed.

For these times, it can be helpful to think of a photograph as a story, and revisit each element of the plot or narrative to check for gaps.

Analyze a photo

Consider each of the following:

WHO

The 'who' of your photograph can be explicit, such as a person or animal we can see, or implied – like mess left by a child, or a book and a blanket left under a tree in the shade. Sometimes, the viewer themselves is the 'who' – the person who the story of this photograph is happening to. This is especially popular on Instagram, where we're so often trying to put a viewer into our shoes, and give them a tiny taste of our life.

WHAT

This is usually easy to answer – what are you taking a picture of? I find it helpful to ask myself, 'What's happening?' to take myself beyond 'It's someone with a sketchbook' to, 'It's an artist reviewing her work after a day's sketching at the beach. ' Showing her inky fingers, or a bag containing equipment by her side, might help cue the viewer into more of the story behind the scene.

WHERE

This usually refers to where a photograph's story or moment is taking place. So often when photographing small details we can become drawn in and lose focus on the wider frame. Stepping back can bring some of this context and sense of place to the scene, so perhaps we can see that the table is in a kitchen, and there's a dog at her feet. If your photo is struggling for story, try reframing to add a greater sense of place to the scene.

WHY

This is really about asking yourself, why are you taking this photograph?

- What prompted you to pick up the camera and shoot?
- Was it that something was beautiful, or interesting, or surprising, or odd?
- How can you make sure you capture that fully in the frame?

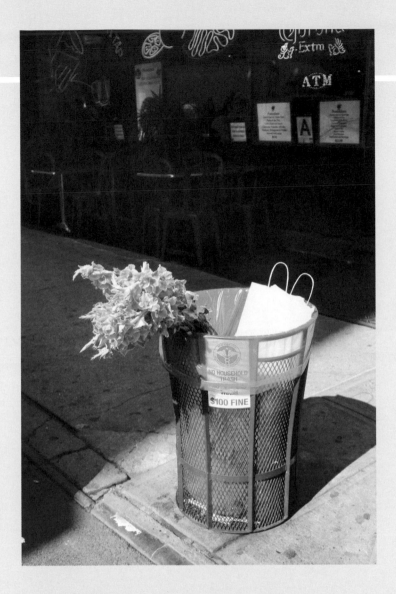

For example, I spotted these flowers in a bin in New York City on a hot summer's day. They were striking in their colour and beauty against the urban landscape. I needed to include the 'where' of the city street in order to answer the 'why' – because they were surprisingly juxtaposed. There's never a bad why, and the point is not to question your motivation – unless of course you're just taking a photograph for Instagram likes, which we'll get to in due course.

FINDING YOUR STYLE

*Finding your Instagram style means diving in and discovering you – the real you; your personality, your loves and dislikes, and your voice. Even if the temptation to mimic others is there, only when you build a feed of images that you enjoy, write captions that you want to write, and essentially, show people the real *you* will it result in an invested and engaged audience who love, respect and appreciate what you do and the work that you share.*

@allthatisshe, UK

Sometimes you'll land on an Instagram page that just resonates. Every picture is more spellbinding to you than the last; you find yourself clicking compulsively, amazed that someone could capture all that you love and distil it to such succinct squares of beauty that make you feel so much.

You might have a wobbly moment of self-doubt where you think: 'I should probably just give up now! I'll never be able to take pictures like this.' And the truth is that no, you won't – because you'll be taking them like yourself. But that doesn't mean you won't enchant people just as much.

It's no accident that these inspirational photographers create such compelling, absorbing work, and it's no coincidence that you like everything on their page. What you have stumbled across in these moments of magic is a creator with a really clear understanding of their own style direction. A clear and coherent creative voice.

We see this in all creative pursuits. In magazines, in fashion – that knock-out designer, or that person you know who always looks super together and

chic. It applies in wedding styles, in interiors, in branding, in art. Knowing your style, and refusing to be distracted from that path by what everyone else is doing is an acquired and artful skill.

Few of us are born with it instinctively, and for most it is found through an ongoing process of trial and improvement. But when you nail it, you will know – by the way it resonates with other people like you, and the way it feels expansive and intuitively right. The trick is figuring out the difference between what you like and what you are. For this, I like to use a wardrobe analogy, as it's an area many of us are used to considering in our own shopping and dressing routines.

In my early twenties, I was an impulsive shopper. Every month on payday I'd head to the nearest mall and grab whatever caught my fancy – black faux-leather leggings, a one-shouldered red top, a vintage peach negligée, a pair of nude leather ballet shoes (it was the 2000s, ok?). The result was always a complex and, honestly, quite baffling mix – things that couldn't and shouldn't be paired

together, that I always needed to buy more random things to put with in order to wear. Getting dressed each morning was a complex mission of sorting and matching, and my identity lurched from goth girl to urban fairy to occasional vintage chic. Not only this, but I was always depressingly broke.

All of which is fine, and for many of us that's what our twenties are for – trying on different personas, working out which feels right. But as I approached my thirties I had a bit of a revelation: the aim wasn't to try and buy everything I liked. And being a student, and then a National Health Service worker, for all of that decade, I hadn't been truly buying all the things that I liked anyway – I'd been buying cheap knock-offs, eBay hand-me-downs two sizes too big, and never really nailing any style.

I had to sit myself down and realize that clothing in stores was not akin to lost, homeless kittens that I needed to take home. I could be more discerning in my shopping.

When I did this, something magical occurred. Gradually, those confusing, hard-to-wear items disappeared from my closet, and my cupboards became less chaotic and full. Mornings became infinitely more simple as everything I owned began to share a common style. And I could finally begin to invest in better, more expensive pieces, safe in the knowledge that this was my own personal style and something I would love long term. I'd finally found my true fashion style, and though of course I've deviated off path now and then along the way, the lesson has never left me or my wardrobe again.

We can use this as an analogy for photography too. It's possible to have many different inspirations – minimalism, riotous colour, moody black-and-white portraiture, hazy vintage film – but we cannot make each of those genres a stand-out feature in our cohesive voice. We might adore all of these styles, but we cannot and should not try to reproduce them all in an Insta selection box of delights. Like my wardrobe of old, we would end up specializing in none of them, never devoting ourselves to it fully, and never really feeling like our self.

The trick, instead, is to take inspiration from all that you love – be it photography, fashion, food or beyond – and put that back through the filter of your own true style. Retell that feeling you get from your inspiration, and put it into your own, unique and consistent voice.

FINDING YOUR VOICE

Finding this filter, this imprint of yourself, can be surprisingly hard to do. Many of us have had a lifetime of hearing other people's opinions on the world, and doing our best to people-please and fit within it. Over time this can make us lose sight of our own true opinions and tastes.

A good place to start getting to grips with this again is to review your photography and life as a whole. What common themes occur across multiple areas? What are you passionate about, both online and off? What makes you feel fired up, and what makes you feel at peace?

Next, it's time to look at what imagery already speaks to you. On the following pages is a simplified version of an exercise I do with all my students and clients that I find to be useful at any stage of the creative journey. In a world with so many inspirations, influences and opinions, taking the time to refocus and redefine our boundaries can keep us on track and stop us from losing our sense of self and why we started in all the noise.

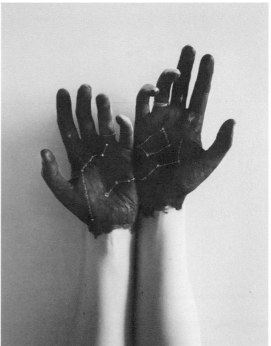

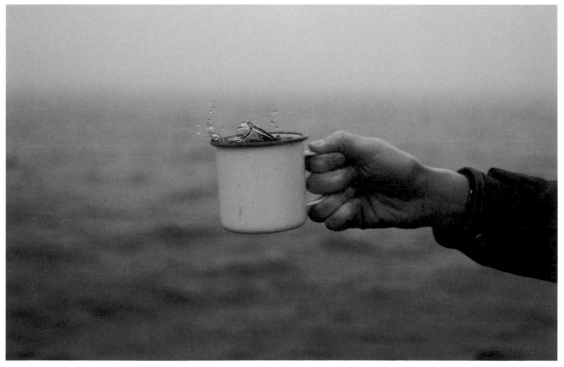

Naming your visual style

1. **Hunt out the images you love most**

 Some might be your own, but others might be on other Instagram accounts, on blogs, in magazines, fashion look-books, movie stills or advertisements. Save them using the Instagram 'bookmark' feature, by taking screenshots or snapping quick pictures with your phone.

2. **Gather them all together**

 I love the board-making sharing site Pinterest for this, but you can always go for good old-fashioned paper-and-glue – and choose around 8–10 that you really adore. You're looking for the images that you'd love to have taken (or are happiest that you did). The ones that feel like everything you love in a single frame; that you could look at all day and never get bored.

3. **Now – what do these photographs all share in common?**

 Grab a piece of paper and write down anything you notice – the mood, the atmosphere, the light, the colours, the subjects, the scale.
 - *Are they shot up close to the subject, or from further away?*
 - *Are they bright and sunny or darker and more shadowy?*
 - *Are the tones warm (nudging towards yellow, red, amber and orange) or cool (blue, grey and white)?*
 - *Are the images uplifting and fun or more complex or melancholy?*

4. **Take a look at all the words and phrases you've listed: these are your visual framework**

 Whenever you're shooting and editing, these are the elements you're aiming to capture and enhance. It's a reminder of what you're working towards. It doesn't matter if these words won't mean the same to anyone else or even if they're not real words at all. It's a list just for you – a filter that shows what you most want to share and how you will capture it.

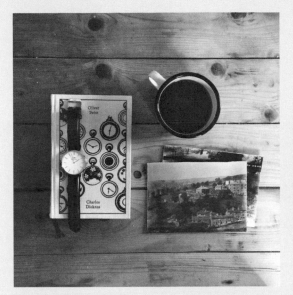

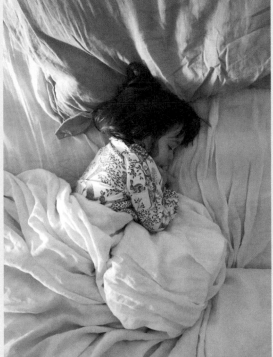

It's useful to put your style into words like this for two reasons:

- Firstly, it's far better for our self-belief to refer to a list of values and qualities than it is to constantly compare ourselves (usually unfavourably) to that board of perfect, best-shot, stars-in-alignment images.
- And secondly, because these words can become an easily applied checklist to run through whenever we're struggling to make a shot work.

To apply your list, simply check that your creation fits into one or more of the qualities you wrote. If it doesn't, what can you change? Is it possible to add in a missing element from the narrative to bring the picture together? Can you edit differently to bring out the right mood?

THIS OR THAT

If you're struggling to think of key words that might work, run through the list below and circle which one you most identify with from each pairing.
(If you really can't choose between two words in a pair, then circle them both – there are no rules that can't be broken!)

Then, narrow the results down to the words that feel most important and reflective of you and what you hope to create.

VINTAGE	/ MODERN	CURATED	/ CASUAL
COLOURFUL	/ MUTED	SLOW	/ FAST
CHEERFUL	/ MELANCHOLY	FADED	/ SATURATED
DETAILED	/ MINIMAL	POPULAR	/ NICHE
FUN	/ POIGNANT	HONEST	/ STYLED
YOUNG	/ MATURE	INDOOR	/ OUTDOOR
MOODY	/ BRIGHT	WILD	/ ORDERED
URBAN	/ RURAL	HOME	/ AWAY
ARTISTIC	/ AUTHENTIC	SPONTANEOUS	/ PLANNED
DARK	/ LIGHT	COOL	/ WARM

FINDING YOUR NICHE

One of the most common mistakes we can make – online, and in day-to-day life – is trying to please too many people at once. Again, this is especially true for women – we're raised to believe that our value relies on being liked and approved of by everyone we meet.

The problem with trying to be liked by everyone as a creator is that we wind up being bland and unremarkable – liked well enough by many, but truly loved by nobody at all. In trying to please everyone else we end up losing sight of what makes us unique. When I think about the creators I am most passionate about – authors, singers, musicians or photographers – it's always their point of distinction that makes me adore them so strongly.

Lean into whatever makes you different, and unique. As multi-Grammy nominated, 12-million-album-selling singer Tori Amos puts it: '*I know I'm an acquired taste – I'm anchovies. And not everybody wants those hairy little things.*'

Everyone likes Margherita pizza well enough, but not in the same way that some people love anchovy pizza. Trust that in being yourself, you'll attract your true audience – and with over 800 million users currently on Instagram (and growing fast), that there's enough to go round for everyone.

That said, it's important not to be too restrictive, either. On social media, we often see super-niche accounts grow incredibly quickly – ones dedicated to a pet, for example, or to recreating the same shot again and again. This can be a lot of fun, but in the long run has the risk of becoming quite restrictive. Owners of highly themed accounts often find they're unable to post anything different or evolve their work as they outgrow their original theme.

For that reason, I always encourage people to leave enough space to wriggle and grow within their niche, in order to future-proof the account they are building.

Listening to yourself

JOURNALING PROMPTS

Below is a list of journaling prompts to help you dig into what makes you tick. If you're anything like me you're probably planning on just skim-reading these questions then skipping ahead – I get it, I do, but I encourage you to go find a piece of paper, or open your smartphone notes, and actually give your brain the time and space to write these answers. We're so good at drowning out intuition in our daily life, so giving yourself 10 or 15 minutes to actually listen can feel like a creative awakening all in itself.

- **What are you passionate about?**
 What are your specialist subjects or obsessions?
 What are you inclined to get a bit ranty about if the topic comes up?

- **What makes you different from the other people in your life?**
 What are your unusual or unpopular opinions?
 What parts of you do you feel like nobody else around you gets?

- **What would you create if you couldn't see the numbers?**

- **What colours most resonate with you?**
 Look to your wardrobe and interiors if you struggle with this.

- **When do you feel most like your true self?**
 This is a physically expansive feeling – like you have room to stretch out and grow.

- **When do you feel trapped or confined?**
 This is the opposite – a claustrophobic feeling, like you're being restrained or made small.

- **A favourite photograph I've taken is…**

- **I love it because…**

- **I'm inspired by…** (things that make you want to create.)

- **I'm distracted by…** (things that throw you off path.)

Keep in mind that your creative voice and what it wants you to create might be totally different from anything you've created so far. If you've already got an Instagram account and you've never considered these questions before, it might mean a sudden change of direction – that's totally fine, and nothing to worry about. Or perhaps you're already nailing a lot of your creative style, and your answers will just help you pinpoint a few areas where you can refine it and be more streamlined and definite in your approach. There are no rights or wrongs here.

EXAMPLE ANSWERS

Here's how a client, Josie, answered these questions when we worked together.

- What are you passionate about?
 Home, family, decorating and my friends.

- What makes you different from the other people in your life?
 I'm obsessive about creating a beautiful home. I know most people think it's superficial or silly but I believe it really impacts on how we live, and can help us live the lives we really want with our families.

- What would you create if you couldn't see the numbers?
 I'd probably share more pictures of my home and more creative pictures of my kids. But I worry what my friends would think – I usually just share snaps of the kids from days out or things I've bought for the house.

- What colours most resonate with you?
 White, green, sand and metallics.

- When do you feel most like your true self?
 When I'm in a space I've designed and decorated. When I'm in nature.

- When do you feel trapped or confined?
 When I'm in a space that is poorly designed or decorated, like a bad hotel or my friend's cluttered house (I'm not judging her, it just stresses me out!).

- A favourite photograph I've taken is…
 The portrait of my kids in the kitchen making breakfast.

- I love it because… *it's my two best creations, the kitchen and my babies, all together. It's lovely and bright and shows how the right space can make moments like this possible. We never did things like that together in the old flat!*

- I'm inspired by… *Pinterest, photo recipe books, being in nature, the Ikea catalogue!*

- I'm distracted by… *other people's Instagrams and what my friends are posting or might think of my photos. Also the photos everyone takes on Instagram like blossom trees and food!*

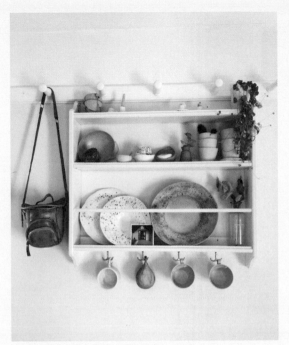

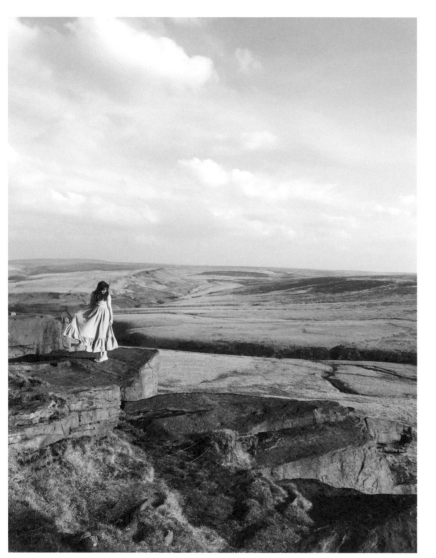

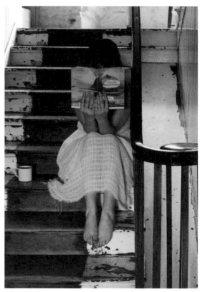
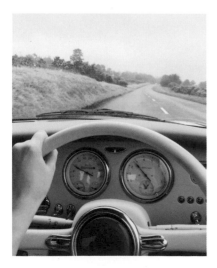
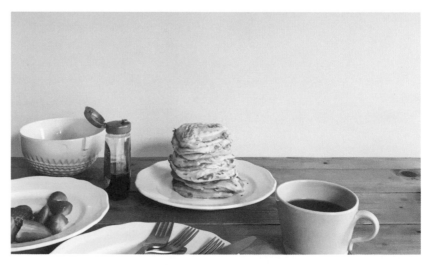

DO SOMETHING WORTH PHOTOGRAPHING

Some days your life just doesn't feel Instagram-worthy. Hell, nobody is photo ready all the time, and nor should we be – but when our daily life fails to inspire us, it can stifle creativity as well.

If you find yourself in this situation, my advice is this: *do something worth photographing.*

- Bake a cake
- Make soup
- Take a walk
- Buy yourself flowers
- Build a gorgeous cardboard puppet theatre with the kids

For a long time I got hung up on the question of whether it was vanity to do things just so I could take pictures of them, and if this somehow made me a terrible person. Eventually I realized: our lives are made up of the things that we do, not the reasons we get started on doing those things. Do something often enough and it becomes who you are.

Does it matter that you only started dressing the table for dinner because it looked nicer in photographs? When you're eating cake instead of hiding under the duvet on the sofa, I think you'll agree. Motivation is motivation, and we should take it wherever we can get it.

There is however one important caveat. Do it for the photo, for the art, for the creativity – but never for the likes. Following a path to social media validation and points is a slippery slope, and an easy way to lose all sense of self and why we are creating in the first place. If you find yourself falling into this trap, visit the later pages on engagement and community (see pages 179–181), and focus on finding an audience that loves the same things as you.

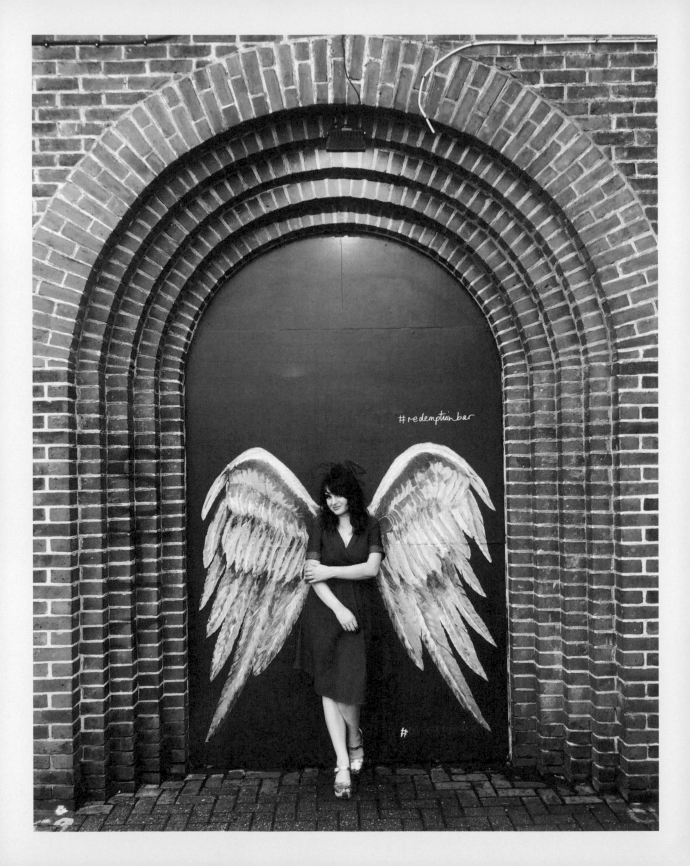

Go on a photo walk

———————

**Pull on your shoes, charge up your camera and head out of your front door –
we're going on a photo walk.**

Exploring the world through a lens can often help us see with a new
perspective – small details can be magnified, and stories reveal themselves.
If you struggle to get into this mindset, a good way to jumpstart is to walk along
literally looking at your screen! Turn on live view mode on your DSLR, use the
flip screen on your point-and-shoot, or simply activate the camera on your
smartphone and use that as your window to the world.

Something magical happens when we frame reality like this – four solid black
lines forming a rectangle around everything we see. Suddenly, everything
becomes a picture, and it's a whole lot easier to tell the interesting ones
from the not.

THINGS TO LOOK OUT FOR:

Tiny details / confetti on a pavement / a single flower in a sea of grass.
Include something like your feet to give a sense of scale, and use your camera's
macro mode if you have it to capture the fine detail.

Unexpected things and juxtapositions / a daisy growing out of an old cement
wall / brightly coloured balloons caught in a dead winter tree.

Little stories of life / *a glowing amber window on a cold winter's evening* /
a child's chalk drawings on the grey pavements of a terraced street.

Seasonal stories / *autumn leaves underfoot* / *the first frost on a windowpane* /
colourful umbrellas in the rain / *a sea of spring flowers at the park.* Seasons tend to
feel most miraculous at their beginning and end for those of us lucky enough to
experience them, but to folks living in the opposite hemisphere or in a fairly static
year-round climate, these glimpses of nature's evolution are like a mini Insta safari.

Insta gold / *pretty houses* / *bushes in full bloom* / *a great shop window* /
a photogenic cat. Sometimes a cliché is a cliché for good reason – because they're
pleasing to look at, and worth holding onto.

Moments of life / *what you bought at the florist* / *the tea from your local cafe* /
the letter as you push it into the post box / *the shopping bag whose handles split, spilling
oranges across the pavement* / *the book you borrowed from the library.*

Different perspectives / *watch your feet as you walk* / *look up to the skies and
the rooftops of the buildings around you* / *crouch down and look at things from a kid's
or cat's eye view* / *share what you find along the way.* Don't expect the best scenes
or moments to necessarily jump out at you. You've likely walked these streets a
hundred times already – to see them with fresh eyes, change your perspective
in the literal sense and get to a new eye-level.

Unexpected beauty / *some particularly poetic graffiti* / *a rainbow of electrical
cables spilling out from a service box* / *a dirty pigeon bathing in a roadside puddle.*
Sometimes the best magic can be found in the stuff that other people overlook.
Clichéd as it may sound, there really is beauty in everything, and training your eye
to see it makes for a much more colourful life.

*NB: You know you've perhaps taken this one too far when you find yourself, like me,
reaching for the camera upon discovering a perfectly heart-shaped bird poop.
#NoSara #Justno.*

If that last pointer has you hiding behind your hands, you're not alone. It's incredibly common when starting out to be afraid of what other people might think – it's scary and vulnerable to try something new and unusual in public!

Here's what I tell myself when those feelings hit:

1. **I'll regret walking away from the picture more than I ever regret taking it.**
 Believe me, you remember the amazing pictures you missed for life, but nobody remembers the random stranger who gave them a bit of side eye in the street.

2. **We're just guessing what other people will think!** Despite how it might sometimes feel, we don't actually know what someone thinks unless they tell us – otherwise it's all just assumption and fear talking. Yes, someone might find it a little surprising – but someone else might find it incredibly inspiring and take it as permission to try their own thing out too! How can we possibly know?

3. *'It is a sign of great inner insecurity to be hostile to the unfamiliar'* – Anaïs Nin.
 If someone's alarmed by you doing something a little bit different, that's on them, and not a burden we should be carrying for them. If you're not hurting anyone or getting in people's way, there's really no reason for folks to mind. We can't please everyone, and it's foolish to try.

MAKING PICTURES

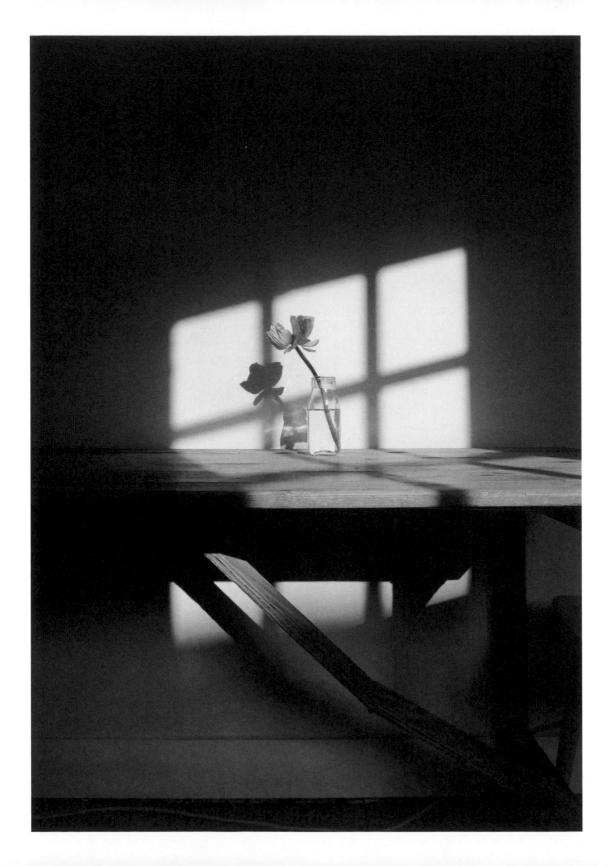

COMPOSITION IS KEY

We make images to see clearly, then we see clearly what we have made.

Wright Morris

It's one thing to find the pictures we want to take. Making the result on the screen accurately reflect what we are seeing can be another skill entirely – what to include, what to leave out, what the light is doing, what the angles mean.

When I was little I used to dream of taking pictures with my eyes. A long, slow blink to capture anything, exactly as I could see it, with none of the difficulty of finding a camera and persuading it to play along. I could never understand why the pictures I took on my camera – a yellow plastic one I'd received as a gift after having my birthday party at a fast-food restaurant – weren't as wonderful as the scene I'd had before me at the time.

The truth is, our eyes do only half the work. When we look at a scene – a smiling infant, a colourful parade, steam curling from a coffee mug in a shaft of afternoon sunlight – our brain does a series of complicated manoeuvres to enhance our focus.

In Speech Therapy I was taught that babies cannot distinguish background noise from important voices. It's why having the TV or radio playing can be bad for an infant's language development; they miss precious exposure to their mother's speech among the hum of household activity.

In many ways a camera shares this naive, open approach to the world. Our camera has no discernment or filter for what is of interest or what is before it. Like the eyes, it simply sees – it is up to us, with our brains, to control, filter and adjust what it records. To make sense of the chaos and tease out the meaning.

In this chapter we'll get into the practicalities of doing that – with whatever camera you have at your disposal, and whatever skills you already possess.

These days it feels like Photoshop makes almost any image possible. Auto modes on cameras are more reliable than ever before, post-production software can correct a whole world of errors, but there remains one element of photography that cannot be faked, cheated or skipped over along the way: the art of composition.

Get it right, and you'll find your audience will forgive any technical missteps. Fail to master it, and no amount of post-production tweaking or filter application will make your images really sing. Composition is the beating heart of any image. It's the nuanced thing that makes people look and linger and feel, and it is the simple bare bones of the picture, the scaffolding that holds it all together.

COMPOSING FOR INSTAGRAM

If you plan to make Instagram your main sharing platform, it's worth sparing a moment to consider the way your work will be seen. Just as an artist might make a commission to fit the space where it will be exhibited, we can make subtle adjustments to our photography to help it stand out or to create maximum impact on the end user's screen.

For Instagram, we know that almost everyone will be seeing it via their smartphone app – Instagram regularly release statistics that make this very clear. Very few users are browsing from a laptop, say, and the 'desktop' site offers limited functionality besides.

This app-heavy user base means we know our audience is essentially looking through a small, handheld, portrait window to see our images – and if they're anything like me, that 'window' can often be scratched, smudged or in need of repair!

So what does this mean for our composition? Well, perhaps that very small, fine detail might easily be missed, and that imperfect quality or resolution might be more easily overlooked. As screen sizes and resolutions increase (and the glass becomes less smashable), this will probably evolve to become less forgiving, and the bar will be raised. Indeed, already, early smartphone images that displayed fine in the initial days of Instagram look noisy and grainy on modern screens.

It's worth remembering, as well, that the app only ever displays content in portrait mode – meaning that users only ever hold their phone in its upright position, and see everything on a tall and slim screen. It stands to reason, then, that horizontal or landscape images shared on platforms like Instagram tend to see statistically less engagement – in no small part due to the fact that they command substantially less screen space. A landscape image can appear as much as two thirds smaller than its portrait counterpart (see the examples opposite) – with direct consequences for how engaging an image is, and how much other distracting content gets seen alongside it.

Of course, that doesn't mean we must only ever take portrait images or video – but when shooting for Instagram, it often pays to consider what sort of screen space our finished product can hope to receive.

On top of that, we're all increasingly guilty of having a short Insta-attention span. Most users spend only a second or two looking at every image, double tapping to like and then moving on.

For any image to really reach out through the (dirty/broken) screen and truly grab a viewer's attention, it needs to have something special, an extra impact or clarity. Composition is our friend when it comes to making this happen.

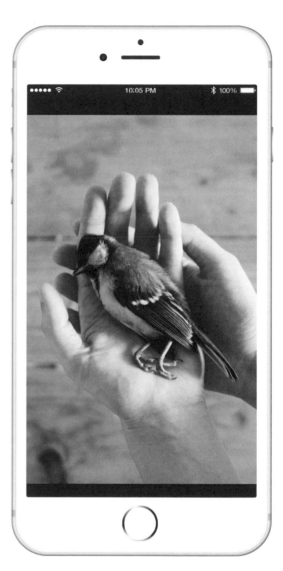

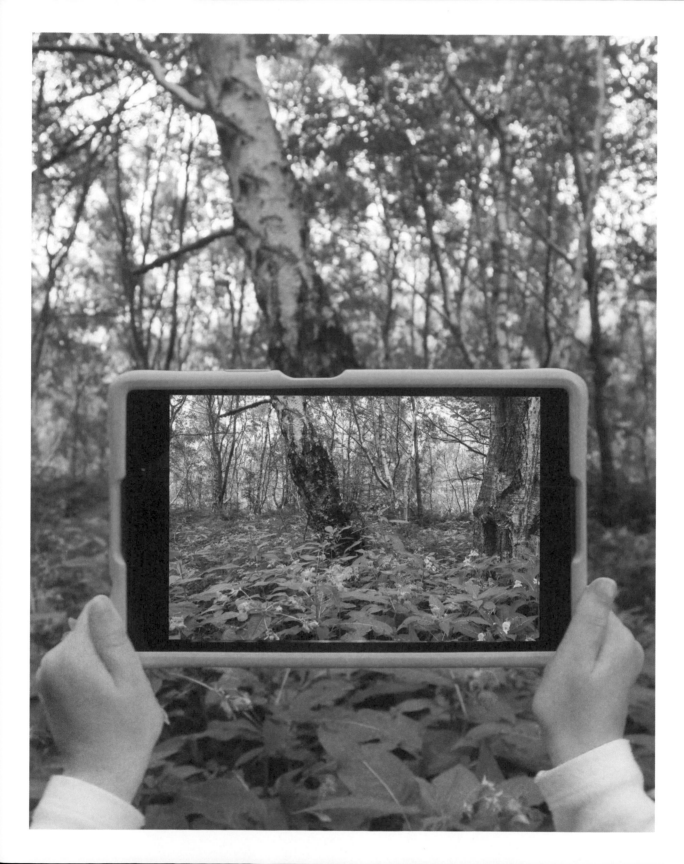

THE SIMPLE SECRETS
OF COMPOSITION

Finding the perfect scene is one thing: translating it from our minds into a photograph is a whole different process, and can be as fun as it is frustrating. While we can always dial our camera onto auto to cover any gaps in our technical knowledge, there's no 'auto mode' for creating a striking composition.

Composition is, as the word suggests, about the building blocks of an image – what our picture is made up of and how those elements are arranged. Understanding the basic rules that photographers apply – whether learned and deliberate, or simply a subconscious process – helps to build images that are strong, engaging and clear.

Of course, there's an argument to say that overthinking composition can kill the creativity. If your style is very honest and journalistic, perhaps you'll choose not to put as much scrutiny into framing a shot as someone looking to tell stories in still-life scenes. But a poem printed onto a white page speaks more strongly in black ink than yellow. Just as with language, our images will best communicate our intended story when they are clear and considered. By reducing distractions, carefully choosing our angles and the elements that make up our scene, we can tell our stories in a way that is accessible to our audience and sings out from on the screen.

Don't think of the ideas on the following pages as rules, then, but simply suggestions. Choose the ones that work for you and feel free to experiment, disregard and break as many of them as you like along the way. And if all this sounds labour intensive and slightly exhausting, don't worry. Once you start seeing these patterns in your shots, they'll become second nature in no time.

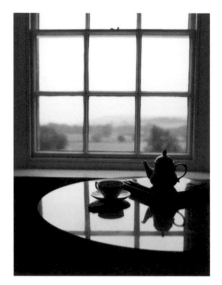

I. STRAIGHT LINES

Tune into the lines that occur naturally around you, both horizontal and vertical – like the sea on the horizon, the level surface of the table or a tall building streaking overhead. Line up your camera so these lines are straight – as accurate to their position in real life as you possibly can.

It can sometimes be tricky to do by eye, but most phones and cameras have an option to display a grid of lines to help you, or a '+' icon in the centre to act like a spirit level and show when your angle is straight. Tilting your phone or camera towards or away from your subject, even just a little, will change how level your natural lines appear, and the angle of your whole composition.

Most editing apps now offer a 'skew' function to correct some of this problem in post production, but taking a strong photo in the first place will always give the best and most flexible results.

WHY IT WORKS

Clean, straight lines are naturally pleasing to the eye, and draw the viewer's attention inwards or along a scene. When they're a little off balance it can be distracting, and detract from the impact of your shot. This is especially true on Instagram where your images appear 'framed' by the phone screen, and are stacked within a square grid. Off-kilter lines jump out to viewers, and take attention away from what we're really trying to show or say.

2. SYMMETRY

Symmetry – when an image is mirrored exactly along an imaginary centre line – always stands out in a photograph, whether it's a mirrored reflection in calm waters or simply a perfectly balanced scene. Spend a few moments getting both you and your camera exactly centred – standing off to one side by just a foot or so can throw all your straight lines and balance off, and spoil the effect. The grid lines are again useful here to ensure you're centred accurately. Pay special attention to where your camera lens is, and where you're holding it in relation to your eyeline and subject.

Remember the whole scene doesn't need to be identically symmetrical for it to work – experiment with placing your subject or one eye-catching element off to one side, but keeping the image similar and balanced overall.

WHY IT WORKS

It's visually appealing and pleasing to the pattern-seeking human mind. Symmetrical images feel balanced and satisfying, with an edge of unusual perfection. Symmetry tends to look great even when cropped by Instagram into square 'preview' thumbnails on your gallery, meaning the impact isn't lost and retains its 'click appeal'.

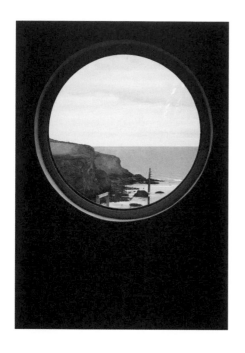

3. NEGATIVE SPACE

This, in simple terms, is the empty space around your subject – and every bit as important as the subject itself! It serves as a contrast to the main event, framing the subject (or 'positive space') and lending a sense of scale and context. Many of my favourite shots are the last ones I snap after I've stepped away – that added distance gives the scene extra perspective and important negative space. Remember, this space doesn't have to be white or even empty – it just needs to be simple, relative to the subject, giving the eyes somewhere to rest.

WHY IT WORKS
Often an Instagram page will be full of tiny, detailed frames, so a shot with lots of negative space can feel like a breath of fresh air and give your audience a moment to pause.

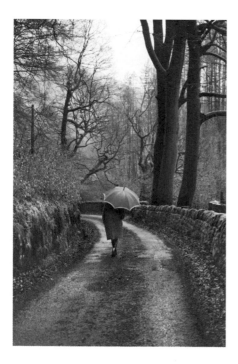

4. A POP OF RED

There's a well-loved photographic convention to add a splash of red to an otherwise muted image, to add a striking detail. Think of a red cloak in the snow, or a single red poppy in a field of grass. Red works well because it's so vibrant, and often there's little to compete with its shade in our compositions – and perhaps because instinctually all mammals associate red with danger and food!

WHY IT WORKS
Adding an unnatural hue to a natural scene can create something eye-catching, and give extra depth and resonance. This contrast stands out to the viewer, even when first seen as a small thumbnail on social media. If red isn't your thing, any bright, unexpected colour can work instead! Revisit the colours you felt especially aligned to in the exercise on page 42, and see which you might incorporate into your images.

5. A FRESH PERSPECTIVE

Experiment with your level and angles when setting up shots. Lean over the tabletop to create a perfect top-down scene. Hang off the fence with one arm so you can get your camera right in among the sheep. Yes, you'll look a little strange, but you'll also get the killer shot. Great photography is a physical and active process, and the chance to gain a fresh perspective in the most literal sense.

WHY IT WORKS

We often look to photography to show us what we cannot see ourselves – be it far-flung places, impossible realities, or simply a different view of the familiar. As Instagram gets more and more popular, audiences grow tired of the predictable shots, and are looking for more engaging and surprising content to draw them in.

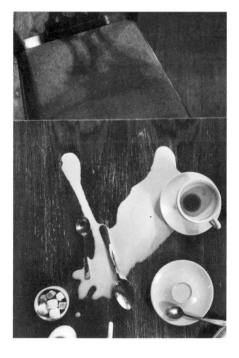

6. DON'T MIND THE MESS

We have magazines to show us a pristine perfect reality; social media's appeal is about real people telling real stories. Embrace chaos and serendipity and see what unfolds, even when you're trying to play by all the rules on these pages! The result is that our images retain a sense of playfulness and casualness, with heart and humanity.

WHY IT WORKS

Perfection is eye-catching and striking, but it's the little imperfections that really hold people's attention, and that can transform an image into a sensory and tactile experience. When we're so used to seeing styled and perfected scenes, a little bit of reality can really hold our interest. How do you feel when you see a ring from a teacup, cake crumbs, lipstick marks on the rim of a mug? They're all evidence of life, and rich with story and nuance.

7. RULE OF THIRDS

This basic composition idea has been used by artists since the 1700s, but remains just as relevant and true today. Put simply, it works like this: imagine two evenly spaced lines splitting your photo horizontally and vertically, dividing your image into nine equally-sized segments. Align the important elements of your scene – your subject, the horizon, any prominent features – with one of these lines, or where they intersect, and you're following the rule of thirds. Photographs composed this way avoid having their subject at the centre, and tend to be evenly weighted, with no single element dominating the entire frame.

If you've never heard of this approach before it can often be best understood when seen in action. Visit meandorla.co.uk/hashtagauthenticbook for links to some video tutorials which explore the rule of thirds in greater depth.

WHY IT WORKS

The rule predicts that lining things up by this grid creates results that are more balanced and visually pleasing to the eye, creating tension, energy and interest. The aim is to bring a sense of flow to the composition, gradually drawing the viewer's eye around the whole scene.

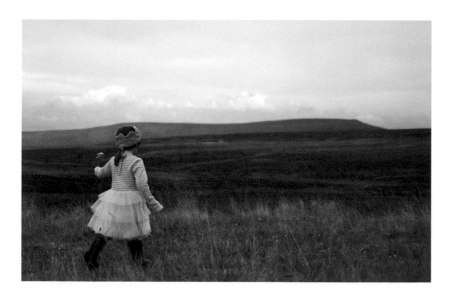

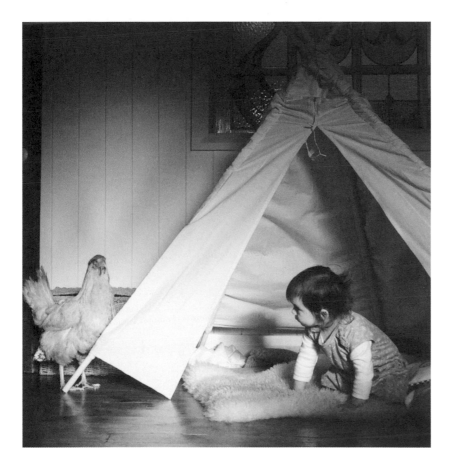

8. FOLLOW YOUR SUBJECT'S GAZE

If your image includes a person, and they're looking in one clear direction, try to create more space in the frame to show what they're looking at – even if it's simply negative space – so you don't leave the viewer guessing. There is so much narrative in the way a subject holds themselves and is interacting with their surroundings – experiment with having your 'model' look to camera, in different directions, and standing with their back to the lens.

WHY IT WORKS

Showing what your subject sees avoids making a viewer feel frustrated, or like they're missing part of the scene. It makes it easier for the viewer to imagine themselves in the image, and understand the story behind the screen.

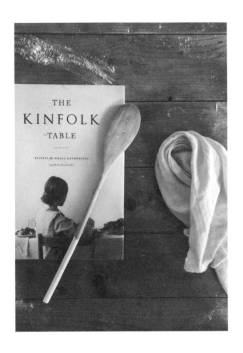

9. BACKGROUNDS

We don't all live in those perfectly 'Instagrammable' homes – and what a boring world it would be if we did. But if you're shooting products, meals or flat-lays and don't have your dream rustic tabletop to hand, there's a simple way to fake it: printed vinyl backgrounds. Similar to those printed plastic tablecloths you had at school, they come in a limitless array of patterns, pictures and prints. There are small ones for tabletop shots, or huge wall-sized ones to hang up for outfit captures or family shoots. Search for them online; I find it's worth paying a bit extra for better quality.

WHY IT WORKS
Sometimes the right background allows the subject of an image to really sing – whether by adding a missing element to the narrative or simply by cutting back on distraction.

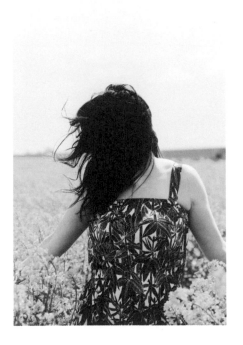

10. BALANCE AND TENSION

This is in every art form and type of design – the tight-fitting bodice that flares out to a full skirt on a couture dress; the soft piano interlude in the music that slowly builds to a dramatic crescendo. Balance and tension make things satisfying, moving, enthralling and beautiful. Learn to look for this in your imagery, and play around with it. How much negative space should you include? What colours work together, or against each other? What can you add or subtract? It takes practice, and trial and error, but you'll know when you start to get it right.

WHY IT WORKS
This is more about how an image feels than anything that can be measured with ruler or ratio. When the tension is just right, an image feels satisfying and complete, like you're seeing all the parts of a whole.

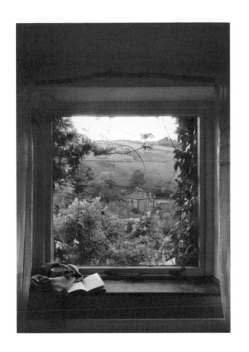

11. NATURAL FRAMING

Occasionally nature or architecture will lend us a hand and provide a perfect frame for our scene. Consider this landscape from my window. How does the window frame add a sense of moment and scale? Would the image be as intriguing if it were only the landscape, with no indication of where it was seen from? Most of the time, context can enhance an image and add to its narrative.

Keep an eye out for the details that are framing your perspective whenever you spot a potential scene, and play around with these to create a scene uniquely your own.

WHY IT WORKS

By making use of shapes in our natural surroundings we can draw our viewer's eye into the subject of our image, and build that effect right into our scene.

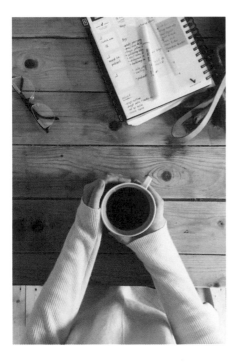

12. SEE WHAT I SEE

Instagram has become almost synonymous with this style of image. It's all in the angle – top-down photographs of coffee cups on a table; feet standing outside a florist; a mum looking down on her pregnant bump. The idea behind all of these shots is to put the viewer in the place of the photographer, and let them 'see' through our eyes. It stems back to a time when Instagram was used much more instantly, and images were taken and shared throughout the day. Nowadays, most people post after the fact or at regular times, but this trend has continued, and remains a great way to bring people into your world.

WHY IT WORKS

It's a powerful way to share your perspective. It feels quite documentary-like or journalistic – like we're in a real moment with you.

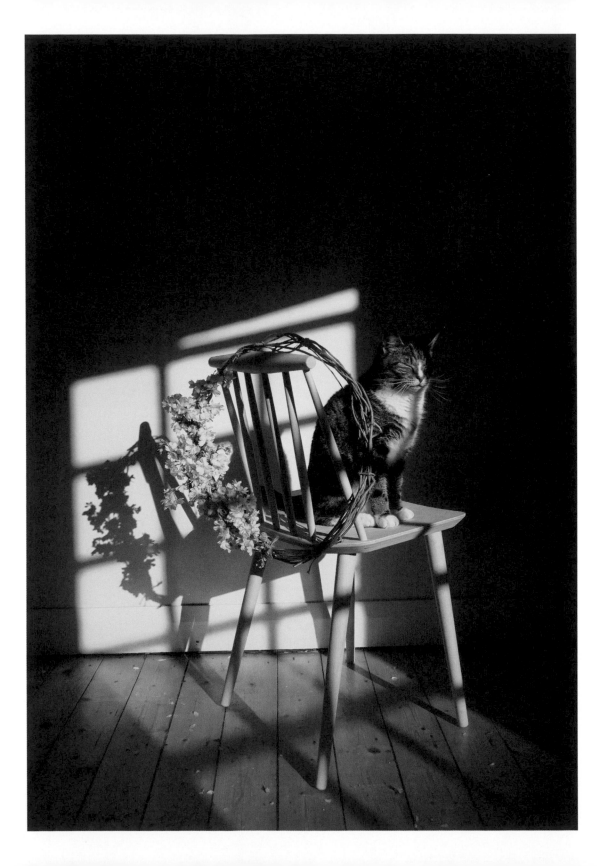

CHASING LIGHT

Light can be the most emotive part of an image.
Working along with it adds something that you can feel when you see it.

@meliamelia.co, UK

Light is the stuff that photographs are made of. It is the paint we splash onto the canvas of every image we create, and the thing that can most transform any image or scene into something flat and lifeless, or something magically alive.

To make sense of this, it's worth thinking about how both the camera and human eye work. When we look at any object or scene, we are not seeing that object itself. Instead, we see the light that is bouncing off its surface – a bit like the echo-location of bats and whales, only visual, and full of colour and shade.

It stands to reason, then, that the source of that bouncing light is the most important factor in how any scene appears, both to our camera and to our eyes. The light cast out by a single yellow-toned lightbulb is entirely different from the bright glow of daylight pouring in through endless windows and doors.

Think of light as different types of paint, then – and natural daylight as the very best you can find. Artificial light sources – like flashes, lightboxes, desk lamps and strip lighting – can all still be used, in the right time and circumstance. But think of it like switching from fine, artisan watercolours to a cheap pot of kids' poster paint: it takes a higher level of skill to create something of equal beauty, feeling and quality.

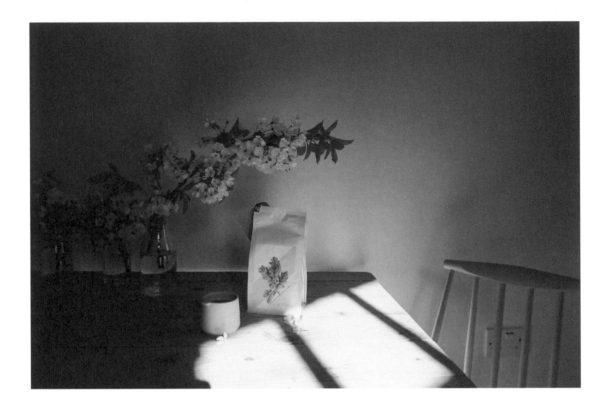

WAIT FOR DAYLIGHT

In most scenarios I advise just waiting for daylight if at all possible. Sometimes it isn't – there's an event or moment unfolding before you, and artificial light is all that there is. In these moments that light can become a part of the story, telling the time of day and immediacy of what you're capturing on screen (see Every Picture Tells A Story on page 28). But for everything else, it's usually possible to step away, and come back to it by morning light with a fresh approach and a bright and beautiful paintbox.

OPTIMIZE THE LIGHT

If you're shooting indoors, especially in a cold climate or during cloudy weather, you might still find light is a limited resource – even by day. Your camera or phone has lots of technology to help you adapt to this, but there are also physical, practical things you can do to maximize the light in any given room.

Firstly, clear off the windowsills! Stacks of books, vases of flowers, picture frames and bric-a-brac all look innocuous enough, but it's amazing how much light they can block. Likewise, pull back your curtains as far as they can go; fully open the blinds, or even unclip them if it's easy to do. If you have dark-painted walls or surfaces, draping them with white fabric or propping up spare sheets of white cardboard can work wonders at reflecting the natural light, opening up the space and giving you more light to work with.

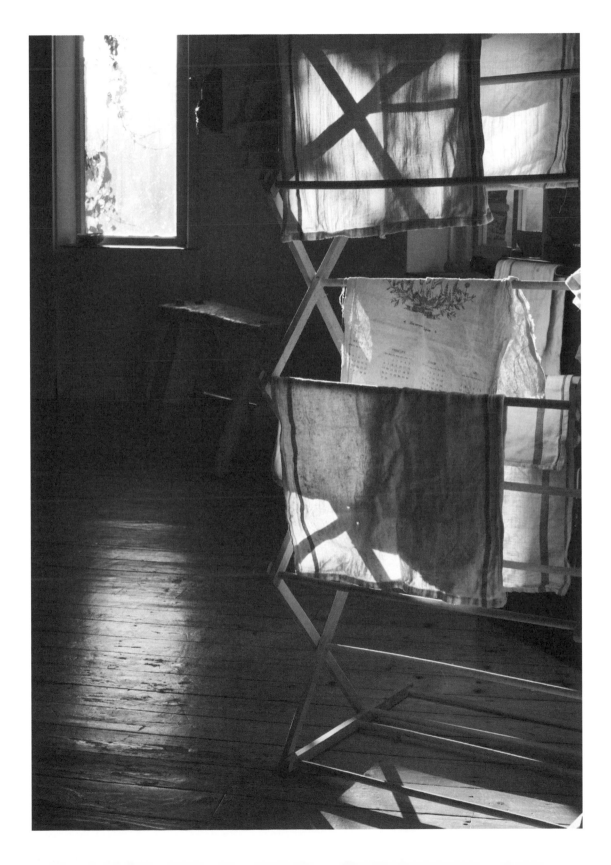

Likewise, mirrors, cheap folding photography reflectors and even a lick of white paint – where practical – can be valuable tools to increase the brightness of any indoor space.

Of course, this isn't always practical for a quick, off-the-cuff shot, but if you find yourself shooting regularly in a gloomy spot, perhaps in your home, look at what you can do to make that location less shady, and bring in the light.

PAINT WITH SHADOWS

With light forming such an essential ingredient in our images, a shadow – the absence of that light – is a powerful thing. Whether it's the shade cast by a high-rise building, or the frame of your kitchen window against the sun, a stretch of dark, empty space can have a tremendous impact in your composition and really draw a viewer in. Keep an eye out for interesting shadows and patterns in your day-to-day life, and be ready to snap a picture of what you find. Just like with music, the pauses and empty spaces have as much to say as the details.

BREAK THE RULES

Photography traditionally comes with a whole host of rules – and light governs a long list of these. Thankfully, rules are made to be broken, and as a creative photographer you get to do whatever you find visually interesting. Shoot directly into the light. Let sun flares and artifacts – the coloured patterns and orbs that can appear as a result – paint themselves across your scene. Underexpose, overexpose, highlight the wrong parts of things. Worst case scenario, you learn that something just doesn't work. Best case? You create something beautiful, creative, and uniquely your own.

SMARTPHONE TIP

Most smartphone camera apps offer a simple slider to allow you to change the 'exposure' of your shot – meaning, how light or dark the scene is before you hit the shutter. It's generally best to get the shot as close to perfect before you take it than to try to fix problems in editing after the fact, so play around with this, and don't be afraid to try different settings. With low-resolution cameras and earlier smartphone models, it's generally best to err slightly towards underexposed (or darker) to preserve the details, as overexposure (too bright) is not so easily fixed after the event.

What is it that makes an image stand out among a sea of others? Why do we skim over some without noticing, while others almost compel us to click?

It's something that's fascinated me for years. Naturally, it has a lot to do with the elements we've looked at already – composition, visual storytelling, beautiful light and subject and mood. But there's a final factor that comes into play on platforms like Instagram – something I tend to think of as 'click appeal'.

Browsing online can be a remarkably passive experience. How many times have you picked up your phone intending to check one simple thing, and twenty minutes later discovered you've been sucked into an app?

Most of us are familiar with the idea of clickbait headlines – how journalists and copy editors are having to become increasingly skilled in the art of writing titles that tease, titillate or intrigue readers to try and compel them to click. What we don't often think about is how imagery can work in exactly the same way.

Clickbait works by appealing to our curiosity; it creates a mental itch that we simply have to scratch. We click, not always because we want to, but because our attention has been snagged and we feel compelled to follow it down the rabbit hole.

Photo-sharing site Flickr has an algorithm that works along similar lines. They call it 'interestingness'; when they show a batch of pictures to a range of users, which photographs garner the most attention? Which thumbnails bring the most clicks, comments, likes and saves? The ones that rate most highly are assumed to be the 'most interesting', and are shared with new visitors to the site's 'Explore' page.

I've always liked their term 'interestingness' because it is something we can overlook in our work. We're more likely to worry about beauty, or technical perfection, or the personal significance to ourselves. And these can all be important, of course – but what happens if we shift our focus to how interesting our images can be? How can we make our images more captivating, more engaging, more interesting to the eye?

To work on our 'click appeal' we need to consider how our photographs sit when surrounded by other photography, like on an Instagram Explore page. What qualities are likely to attract people's attention to our work?

Some of it, of course, is simply down to personal taste and interest. The rest of it though is just basic psychology – the impulsive snap decisions that our brains pass down to our scrolling fingertips, long before our rational mind has even had a chance to make any sort of choice.

If you're looking to organically bring more viewers to your images, to grow your online audience or perhaps to make effective adverts for your store or your work, including a little of this 'click appeal' in your photography can be a fun challenge to explore. Just as with Flickr's 'interestingness', the algorithms of Instagram and similar sites seek the content that attracts the most

audience engagement. The more we prompt our followers to spend time on our posts, the more impact our work and our message can have.

Below are some ways you can give images that all-important 'interestingness' factor. Try combining a couple in your work for maximum effect.

ICON-LIKE

A composition that has a graphic or symbolic quality, like the bath picture on page 74. Typically these shots are styled and considered, with lots of negative space, symmetry and strong shapes that form a clear message. The impact of the photograph is normally just as powerful in a tiny thumbnail form as it is on full-screen.

COLOUR

There's a reason that flowers and fruit grow in so many shades: most living things are drawn in by a riot of glorious colour. Whether it's harmonizing colours, colours that starkly contrast, a mass of one single colour or a whole rainbow spectrum, colour-on-colour is a sure-fire way to catch people's eye.

SURPRISE

Any unexpected quality grabs our subconscious. Our minds love patterns and predictability, so anything that goes against that sends up a warning sign. A teacup full of flowers, a sky full of hot air balloons, a cat snuggled up with a bird – anything that contradicts what our eyes have come to expect will tend to draw us in for a second glance.

FINE DETAIL

Small, hard-to-decipher details teased in a thumbnail image compel our curious minds to click. Tease something interesting – an array of beach finds, handwritten diary pages, an incredible view from a small window – and immediately we are captivated and want to see more.

THE IMPOSSIBLE

Similar to the 'surprise', there's a huge trend on Instagram for images depicting impossible scenes, proving popular both with audiences and the 'Explore' algorithm. Creating these images usually requires some skill in clever set-ups or digital manipulation, but it's possible to create them using only your smartphone camera and apps. Think: a coffee pot being poured by an invisible hand, or a small child perching high in the clouds (see Whimsy & Magic on page 151 for more).

CUTENESS

I'd wager this is evolutionary as well: babies, kittens, bunnies, fluffy chicks. Anything that makes you go 'awww' or swells the heart falls under this category. Instagram even has its own hashtag for fluffy animals – #weeklyfluff.

MULTIPLES

Anything in multiples or en masse is naturally compelling. There's something distinctly eye-catching about the pile of Halloween pumpkins outside the grocer's, a sea of flowers at the market. This approach is at its most thumb-stopping when combined with unexpectedness, showing things you don't always see in such large volumes.

NEGATIVE SPACE

As mentioned in composition (see page 62), this is the amount of 'quiet' space within a frame. It makes an image easier to 'read' at a glance while making the fine details smaller and more intriguing.

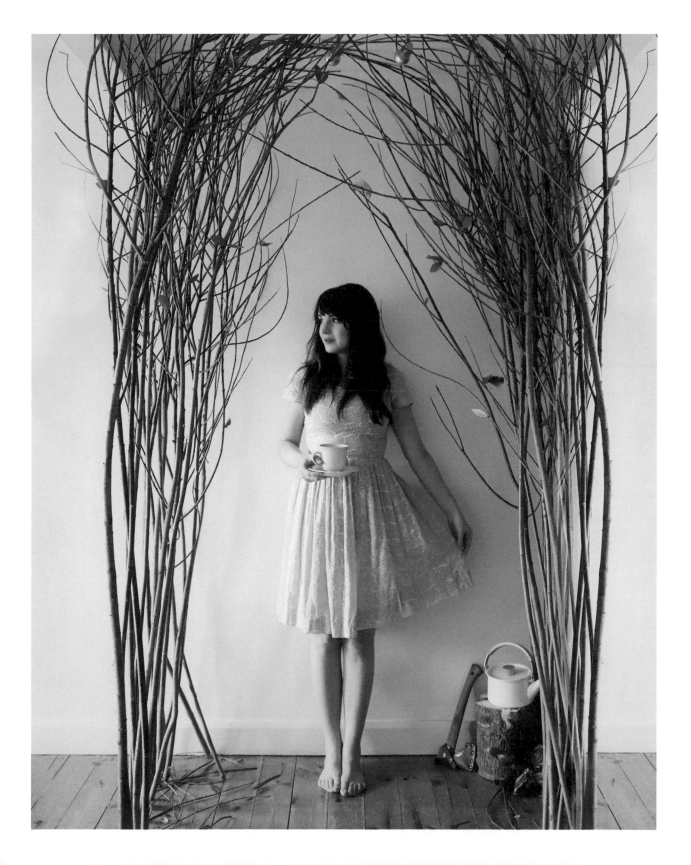

Thumb-stopping imagery

So, you've found your style, and you're busy identifying the moments you're ready to share with your audience. But how can you stand out in a sea of existing accounts and photography?

With Instagram growing bigger and bigger every day, and increasingly flooded with gorgeous, high-standard photography, how can we grab our audience's attention and make a splash?

The answer is in what I like to think of as click appeal, or 'thumb-stopping imagery'.

The basic premise is this: whenever we're scrolling through the app (or, indeed, any app that presents a whole heap of imagery for us to consume), we're processing an awful lot of it subconsciously. When we flick through our Instagram, we make split-second decisions on which pictures to click on and which to ignore – often without even really realizing we are doing so.

You can test this for yourself right now with the following exercise. Don't skip ahead and read part 2 until you've completed part 1, or it doesn't work as well!

1. Open the Explore page of your Instagram app – the one with the magnifying glass in your bottom toolbar. This is a selection of images and videos that Instagram thinks you're likely to enjoy.

 Take a moment now to browse this page as you usually would – clicking for more detail on shots that grab you, scrolling past those that don't. (If there are any shots that are wholly inappropriate or unlikeable to you, go into the post and hit the three dots in the top right, and select 'see fewer posts like this' to let the algorithms know.) But as you do it, pay attention to where your brain and eyes go. Tune in to what does – and doesn't – grab your interest.

2. Now, put your phone down. What images can you remember seeing? Scribble a quick list if you can, with basic points about each, and anything else you observed.

3. Open up the Explore page again and, without refreshing, revisit the grid you just browsed. This time, look for the pictures you didn't see the first time around, that didn't make your list. Were you right to ignore these, or do they hold something for you?

WHAT THE RESULTS SHOW

What tends to happen is something curious – the photos we end up instinctively clicking on are often not the pictures we would intentionally choose given more time to consider. When we make split-second skim-read decisions, we're letting our more primal, basic, subconscious brain make decisions based on values that might not align completely with what our conscious mind enjoys. It's an idea which has interesting ramifications for any system sorting imagery by algorithms and clicks.

Review your images

1. **Review your previous images taken over the last twelve months.**
If you have an Instagram business profile, you can display these by going into your stats and setting the values to show you. If not, it's easiest to browse via the desktop site where you can hover over any image and see the likes and comments count displayed on screen. There are also third party websites that offer to pull out your 'best nine' from a specified time period.

2. **Make a note of which images got the most engagement** – that is likes and comments – over the past year.

3. **What was special about these posts?** Consider them through the lens of what we've just looked at in this chapter – the composition, the click appeal. Are there any key factors that seemed to work for you?

ISN'T THAT A BIT… FALSE?

If this seems like a step too far in the Instagram game to you, then that's totally understandable. Not everyone who shares online cares about reaching a large audience, and there are absolutely no rules or strict guidelines you need to follow to get involved.

But in a digital world that is being perpetually saturated in new, high-quality, beautiful imagery, it would be disingenuous of me to not talk about the factors that make some images stand out more than others, and how we can make use of that.

Follow your heart when it comes to this side of things, and only take on board the tips which help you tell the story you already know you want to tell.

DIGGING DEEPER

Remember, if you're trying to add 'click appeal' to your work, the trick is in finding the perfect balance. Appealing to the subconscious is only half of the task; once we have our audience's attention, the post and caption needs to be compelling and valuable in order to sustain that interest.

THE PHOTO VS REALITY

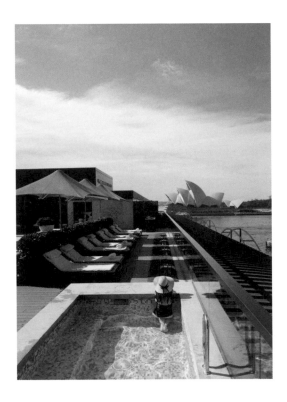

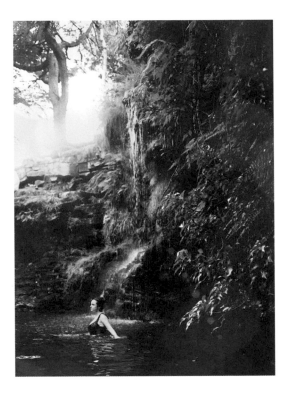

WHAT THE PHOTO SHOWS

A rooftop pool overlooking Sydney Opera House.

WHAT YOU CAN'T SEE

To get this angle I had to make my (poor, long-suffering) husband perch among some rooftop topiary. This was actually a much smaller hot tub, not the main pool, so I had to crouch on the ledge and sit backwards to make the narrative work. Perhaps the scale didn't entirely work, because after I posted it someone assumed it was Orla, and commented to ask why she was wearing white woolly tights! Those are actually just my pale British legs distorted by the water. Oops.

WHAT THE PHOTO SHOWS

Doing my best shampoo-advert impression beside a wild Yorkshire waterfall.

WHAT YOU CAN'T SEE

The group of young boys, just out of shot, dropping into the water from a high rope swing, pulling each other's pants down and generally having summer holiday hijinks. The tick bite my daughter got that day that later turned into a nasty infection and left me irrationally fearful of ever going back.

Some people might argue that these pictures distort reality – that they are dishonest, or show an impossibly perfect life. It's a reasonable point, and something we all have a duty to be mindful of whenever we craft an image to tell a story with a 'happy ever after'.

But the moments were all real and truly existed for me. I really did swim in that amazing rooftop pool; the bumblebees didn't spoil the fun I had taking those floral photographs, and I'm all the

more grateful for the pictures of that day at the waterfall because we might never go back.

For me, this is the true reality. No moment is ever really 'perfect', no matter how hard we try – we could pick apart any smiling photograph and remember the argument that followed, the disappointing food. There are just as many things in life to dislike as there are to enjoy, and sometimes it's just a question of what we choose to pay attention to, and finding the gratitude.

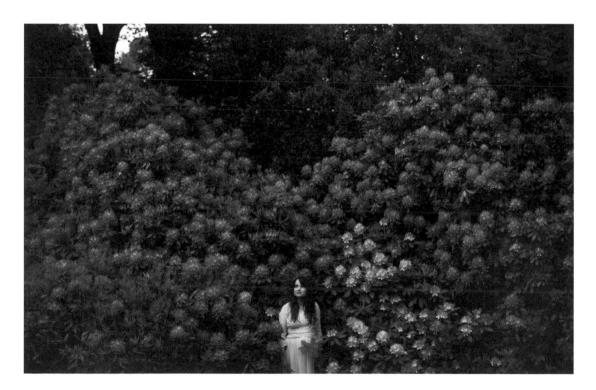

WHAT THE PHOTO SHOWS
Me posing in a happy moment in a bush in full bloom. I shared on my Instagram Stories how this photo came about – a message I sent to my friend, photographer @meliamelia.co, asking if we could go and lurk in some bushes, and we had a lot of fun.

WHAT YOU CAN'T SEE
The flowers were humming with bumblebees and I am faintly terrified of getting stung! Also, the new dress I was wearing didn't quite zip up properly over my boobs, so I had it partially open at the back, exposed to the bush's wildlife!

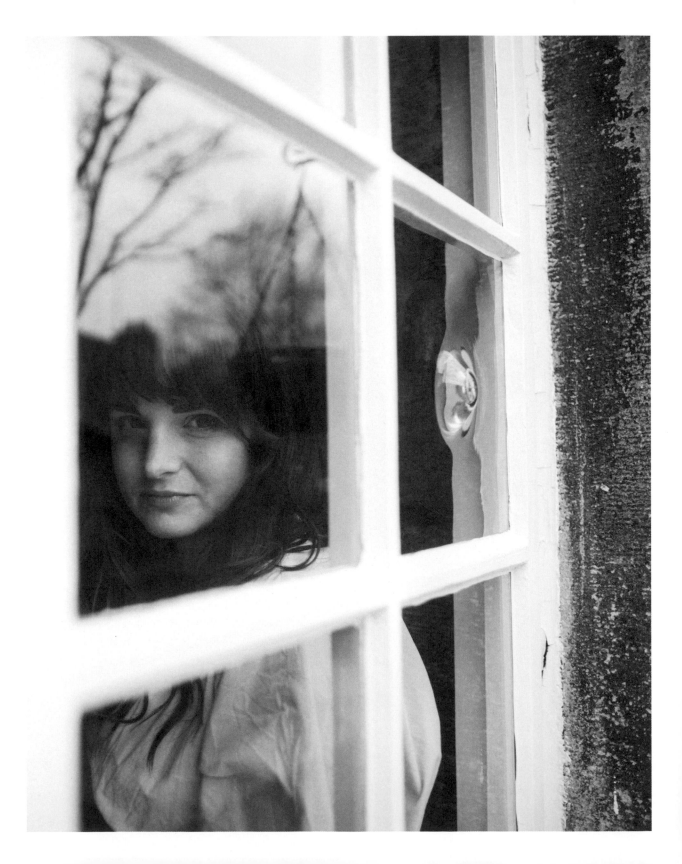

BEING SEEN

For all its reputation of narcissism and vanity, Instagram can be a scary place to let yourself be seen. Actually, perhaps it's precisely because of that background noise of perfect selfies that it feels so vulnerable; if you don't meet the narrow parameters of a typical Internet beauty, it's easy to feel like you're setting yourself up for criticism or rejection by sharing your face online.

It's an especially common problem for women, I find. I have friends who refuse outright to be photographed at social gatherings and events for fear they'll end up on the Internet, outside of their control. They've been made to hate their own image so much that being photographed feels dangerous and unsafe. However robust your body image, most of us can relate to the familiar horror of being tagged in an unflattering photograph on Facebook, leading to days of questioning 'Is that really how I look?'

But there are important reasons for trying to tackle this fear, and learning to take ownership of how we are seen in our own photography and in the images we share on Instagram.

THE INVISIBLE NARRATOR

Whose story are we telling if we never show our face? Before I had Orla, I was fairly prominent in my own photography. I'd shoot outfits or day trips, and was happy to set up a self-timer or ask a friend to shoot a batch of images while I struck a pose or four. It felt normal to me then, and easy.

After she was born, my focus shifted. Here was this tiny miraculous being who seemed to change by the minute – it felt far more important to document this evolution, lest I forget a single second of it. There was seldom time to primp myself to those old photoshoot standards, and nobody to hold the baby if I posed and my husband snapped. Self-portraiture dropped off my photographic radar completely.

I've no regrets about this save for one: there are almost no images of me with my child for the first two years of her life.

Isn't that ironic? In my determination to document her world, I neglected to shoot what was arguably the single most important element of her daily life: her mother!

I've made a conscious effort to change this now, but there are still times when we inadvertently stay hidden behind the lens.

A family party, a special occasion, a wedding or vacation – it's all too easy to get so swept up in the shooting that we forget to include ourselves.

What we're left with is an invisible narrator – a ghost of ourselves in the visual story of our life.

CONNECTING WITH PEOPLE

Next time you're browsing your Instagram favourites, pay attention to what you see of them. Do they feature in their profile image? Are they prominent in their gallery images, or perhaps talking to the camera in Stories? Or conversely, do you have almost no idea what they look like?

As humans we're hard wired to look for faces. Right from birth we have just enough vision to see and recognize another human face – usually that of a caregiver smiling over us at close range. We know that offline, facial expressions and body language are considered valuable sources of information – how many of us hate talking on the phone because all this non-verbal communication is stripped away? Or rely on emojis to replace our own faces in online exchanges? Even babies just a few weeks in age have been shown to understand and react to an adult's facial expressions of happiness or unhappiness.

Meanwhile, a fascinating study from Canada (Bakhshi, Shamma & Gilbert, 2014) indicates photographs with faces attract around 38 per cent more likes online, regardless of age or gender.

It's clear that seeing faces and the physical form of other people is important for most of us when it comes to building connections and relationships – and that makes sense online just as much as it does face-to-face.

Instagram profiles and social media personas that never show the human behind the camera have a tendency to feel remote, stand-offish and a little cold. If our work is wonderful enough then of course we can still grow a following, but it will often be harder to make meaningful connections, gain trust from others and have people relate to who we are. Not because anybody is judging us for it, but simply because it's how humans are wired to operate.

OWNING OUR OWN IMAGE

The third and final reason I encourage everyone to take photographs of themselves is because it can be so healing and empowering. Perhaps you've always been told you're not special, or that exploring your appearance is vanity and shameful. Perhaps your body or face has changed since you were younger, and you've not yet made peace with how you look now. Perhaps you're simply shy, or were bullied, or any number of other reasons I could list.

It doesn't matter really, because the solution is the same. Pick up a camera and shoot.

When we take pictures of ourselves, by ourselves and for ourselves, magic can start to happen. We can learn what we like about ourselves, and how and when we look our best. We can work out the poses and angles that most flatter us in images, and choose to pull these out of the bag in nerve-racking photo situations. Over time, we can reprogramme the way we see ourselves and the story we tell in our heads when it comes to ourselves, our image and photography. And best of all, we can gently dip our toes into sharing that image of ourselves with a wider world, and access the incredible healing power of acceptance and love from the Instagram community.

Ways to make it work for you

1. **Do it alone.** If you're at all nervous about self-portraiture, set aside some time to shoot when it is just you, with nobody to watch you at work.

2. **Take hundreds of photographs.** Take full advantage of digital photography's biggest perk and shoot unlimited shots of yourself. Delete what you hate, and examine what you don't. What can you repeat for your next hundred photos?

3. **Get creative.** Self-portraiture doesn't have to mean a smiling selfie or pose. Dig into your creativity to make something unique and reflective of you as a whole, and not just as a two-dimensional figure. I've done self-portrait series around my love of *Star Wars*, fairytales and even snow, which have all helped me feel less self-conscious and more like my body was part of a larger story or scene. Likewise, don't feel like you have to show all of your face or body for it to count. Just slipping in your hands, feet, hair or part of your face can give people a sense of the human behind the images, and a better understanding of who you are.

4. **Study how others do it.** Start collecting portraits that appeal to you, and think about why you like them. It's seldom about what the person looks like or how beautiful they are. Instead, it's about lighting, mood and story. All the mainstays of what we aim to do as Instagram photographers, and the things we are learning together in this book!

One creative I worked with felt nervous about showing her hands, as she said she felt hers looked older than those usually seen on Instagram. My response was, all the more reason to include yours! There are, of course, millions of women with older-looking hands using Instagram, so why on earth aren't we seeing them more? As well as increasing the diversity of bodies we see, it's a shining beacon to all the other people out there thinking similar thoughts. As someone who can never keep nail polish neat for more than an hour, I relate far less to images of perfectly manicured hands, and feel better seeing ones that look more like my own.

USING A SELF-TIMER AND TRIPOD

Anyone with a simple smartphone or camera can start taking self-portraits right away. Most cameras and camera apps come with a build in self-timer mode – this gives you a delay between hitting the button and the shutter releasing on the shot, giving you a chance to run into frame and get ready for your picture.

If your camera has the option, opt for a 'burst' or 'rapid fire' shot of images, which allows you to move as it is shooting and avoid awkward mid-blinks or changes in expression.

Bendy-legged, flexible tripods are available cheaply online for most lightweight cameras and smartphones, and are handy for attaching to light fittings, banisters, tree branches and other unusual mounts.

TIP
There are heaps of videos on YouTube from models sharing how they pose and look their best in photographs. Nobody looks good in pictures all the time by accident – it's a learned skill that anyone can master!

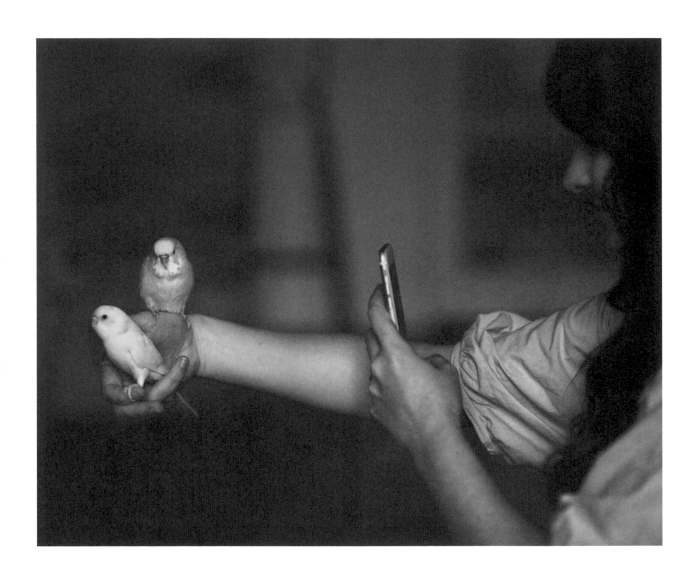

GETTING THE MOST OUT OF
YOUR PHONE CAMERA

Even if you're a devoted DSLR user, I firmly believe you should know your smartphone camera well, too. There will always be times when we need to snap something quickly, and understanding the simple but powerful options offered by a camera phone can be the difference between making or breaking a shot. This is how I make the most out of my smartphone, wherever I am.

RECOMMENDED SETTINGS

Make sure your phone is always set up and ready to go. Mine is always set up so that the flash is turned off (it's too bright and creates ugly shadows), the grid lines are turned on and no built-in presets are activated.

QUICK ACCESS

Practise opening your phone's native camera from the lock screen – it should be possible without having to enter your passcode or otherwise unlock it.

Once you do it enough it will enter your muscle memory, like driving a car, so you can flip the camera open rapidly without thinking. Those precious few seconds can make all the difference when you see something unfolding. I'll never forget the deer lying in the bluebells I missed because I was too slow fumbling to get my camera out!

MANUAL CONTROLS

Smartphone cameras have pretty reliable auto modes, but we can get more control by setting our focus (what the camera is 'looking' at) and exposure (how much of the light it 'sees'). For most phones you can simply tap the subject on your screen, and a box will appear: everything within this area will be in focus and properly exposed, meaning it is bright, visible and sharp. Setting different areas of the scene as your focal point will give different results, especially if there's a lot of contrast in your image – highlighting dark areas will brighten the whole image, and tapping on the bright spots brings the rest into shadow. If you'd like even more control, look into camera applications that allow you to set focus and exposure in different points in your app store.

EXPOSURE & FOCUS LOCK

An underused function on iPhones and other smartphone cameras, AE/AF lock allows you to set the exposure and focus onto your focal point and override the camera's attempts to auto adjust. Simply tap and hold your finger over the focal point for a second or two to trigger 'AE/AF lock', which locks in the current setting until you tap the screen again.

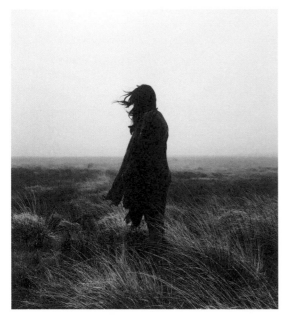

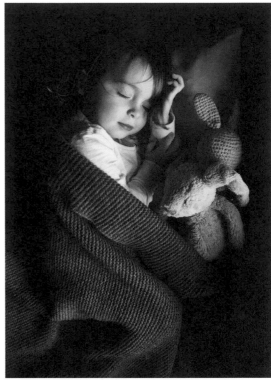

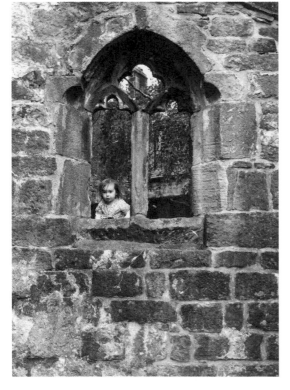

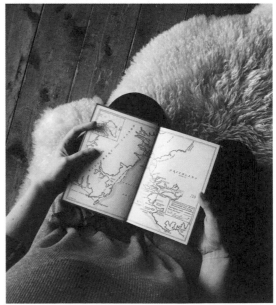

BURST MODE

Burst or rapid fire mode is useful in a range of conditions – especially whenever a subject is moving. Turn it on – usually by holding down the on-screen shutter while taking a picture – to take a rapid succession of photographs without needing to adjust your exposure or focus.

A standard rate for phone cameras is around ten frames or photographs per second – much faster than you could ever manually hit the shutter release. This is perfect for kids, pets, wildlife and self-portraits – anywhere you need to shoot fast to get the killer shot.

HDR

In HDR or 'High Dynamic Range' mode your camera will process your images slightly differently. It's designed to be used when you're shooting a high-contrast scene, such as a bright window scene in a darkened room or a landscape against a bright sky. HDR aims to capture more detail and colour in both areas by taking a range of photographs at different exposures, and automatically combining the best parts of each. Like any automated process the results are variable, so it's best to take your own manually exposed image as well and see which you prefer. Alternatively, on most devices you can set HDR mode to automatically save your 'normal' image as well whenever it's used.

RAW

More recently, some smartphones have begun to introduce RAW file format for photographs. When you shoot RAW, you essentially block your phone's internal processor from taking its usual steps and making adjustments to images, giving you instead a literally 'raw', unprocessed result. The advantage is that this can offer greater control when editing exposure, colour and other variables in post-production, but the file sizes are significantly bigger, and will take up more space. You'll need to download an additional app to shoot RAW on your smartphone – search your app store for the top-rated RAW camera apps.

SHUTTER RELEASE

Your smartphone has an in-built range of options for triggering the shutter, beyond the big round button on the screen. As well as the self-timer, you can use both the up and down volume controls on the side of your phone, or your handsfree headphones to trigger the shutter (on Android you may need to change your camera app settings to do so). This can be useful when you need a little more distance, or are trying to reduce camera-shake – you can even hold it down to take a burst. Alternatively, if you have a tablet or second handset (or can borrow one from a housemate or friend), then there are a range of apps available that will allow you to use that device as a Bluetooth remote. If you don't have a tripod to hand, there's a ton of ways to place your phone for self-timed shots. An empty water glass, masking tape, Blu Tack or propping up against objects - as long as it's steady, static and safe, it will work!

MANUAL APPS

Additional third-party apps can give you more distinct control over your phone camera settings, including separate points for focus and exposure, long exposure simulation, RAW files and more. The technology is always evolving, but I like Camera+ and Manual for playing with these features on iPhone.

GETTING OFF AUTO
MODE ON YOUR DSLR

If you feel like you've got 'all the gear and no idea' when it comes to your photography, you're not alone – it's one of the most common things I hear from budding photographers online. The learning curve from point-and-shoot to DSLR (digital single-lens reflex) is steep and often baffling, and many of us invest in better technology only to find ourselves flummoxed and frustrated and reduced to shooting on auto mode all the time.

There's nothing wrong with that, of course – if you're taking the pictures you want, and are happy with this, then by all means continue. However, if you're itching to understand more, here are a few quick-start tips to get you feeling a little more confident with your camera.

PICK A LENS

A great tip my photographer friend James Melia taught me is when you're learning, pick one prime (non-zoom) lens and stick with it for a year or two. It can sound restrictive, but learning one lens really well allows you to understand distances, aperture and depth of field in a much more intuitive way than if you're constantly switching around. The lens I most frequently leave on my camera is a 35mm f2, which is great for documentary-style imagery, detail shots and creating a soft and moody shallow depth of field.

SHUTTER SPEED, APERTURE AND ISO

They sound scary and baffling (not least because the numerical values are totally counter-intuitive), but shutter speed, aperture and ISO (image sensor sensitivity) are in fact simple to play with and grasp. If you're a total beginner and feel daunted, watch a few YouTube tutorials explaining the basics, then go out and shoot with your camera to experience the differences in settings for yourself. Many photographers don't think in numbers when it comes to imagery anyway, and simply know that they need to 'turn that dial left' if an image is too dark or too light. Learning your camera by feel is a completely acceptable and professional way to work.

SHOOT ON LIVE VIEW MODE

If your camera has a back view screen with a 'live view' option, use this in tricky lighting conditions to preview your settings before you shoot. What you'll see on the screen is literally a live preview of the shot you will get with the current settings, making it easy to see when you

need to dial something up or down before you begin to shoot. If you're used to composing on a smartphone screen, this can feel a bit more intuitive, and help you find your way around the camera in the early days.

ADJUST TO MATCH THE AUTO VALUES

Another way to figure out what to set your values to is to take a picture on auto mode and see what the camera sets to by default. Then, switch into manual mode and programme in these same settings, then play around moving them up and down to get your desired result. Just the act of programming in the relevant values is a great way to get more familiar with the camera, and you'll quickly begin to see how the numbers differ in different kinds of light and settings.

TRY AV MODE

Most cameras offer an 'aperture priority mode', which is sort of a partial auto setting. Manually set your desired aperture, and the shutter speed

and ISO will be calculated for you automatically by the camera to get the best shot. Again, pay attention to the values used in these shots to really understand the dynamic between shutter speed, ISO and aperture.

EDIT ON YOUR PHONE

If you're already wrestling with the learning curve of your DSLR, adding in the brilliant but often daunting power of software like Adobe Lightroom or Photoshop can feel like a step too far. I edit all my images for Instagram using the mobile apps covered on page 103.

To get the images from your camera to your phone:
- Check if your DSLR offers wifi or Bluetooth connectivity. Most modern ones do.
- Look into buying a wifi memory card that can provide this function for you.
- Upload the images to your computer as usual and share via a service like Dropbox or Adobe Cloud to your phone.

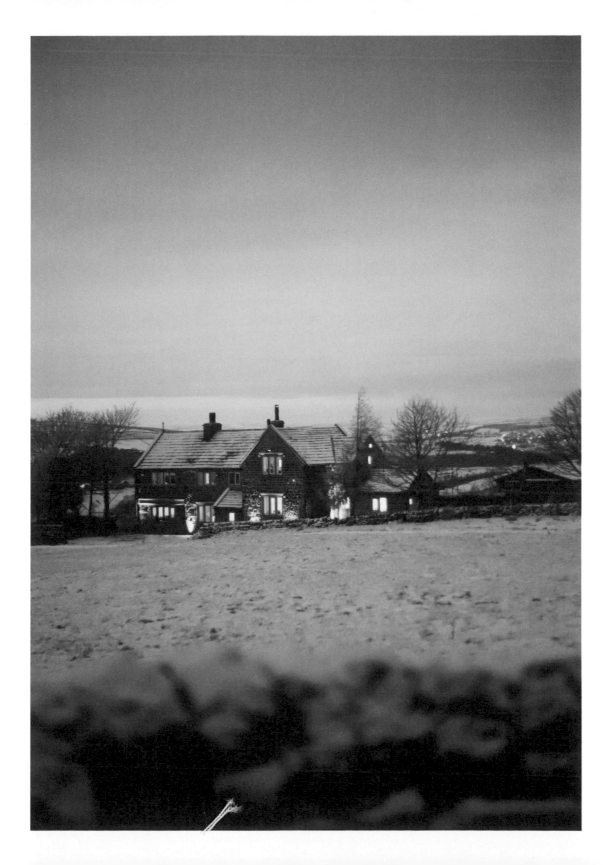

Put it all together

For this exercise we're just going to take a simple, still-life image.

1. **Find something to photograph that is true and honest for you.**
Something like a single flower or stem of leaves in a vase, a fresh pot of
coffee with a cup or an obliging pet cat, perhaps. Try to choose something
short-lived or animated, like these suggestions, instead of a simple static
object: it makes more sense to photograph something that is temporary
and changeable, because it won't be around for as long.

2. **Find your light.** Look for a surface like a tabletop, window ledge or the seat
of a chair or stool, in a space with light that appeals to and interests you.
If it's a sunny day, see if you can find somewhere the light is making patterns
or shadows that you might want to play with. If it's cloudier, head closer
to the windows to get the best light.

3. **Take a picture, as you usually would, for a comparison point.**

4. **Now, apply what we've learned.** Place your object in the middle of your shot,
and use your grid lines to make sure it's centred and balanced. Check that the
horizontal grid line runs parallel to the table surface, and that your phone or
camera is facing straight and not turning to one side or another. If your phone
or camera has it, make sure the yellow and white centre crosses line up. Make
sure you've set your exposure for the brightest parts of the scene. Snap.

5. **Repeat this, but set your object off to one side of the frame.** Align it with
one of the alternative lines on the grid as in the rule of thirds. Check your
angles and exposure, and snap.

6. **Repeat this process in another location in your home.** Play around with
changing the angle and position of your object, as well as the direction
the light falls into your frame.

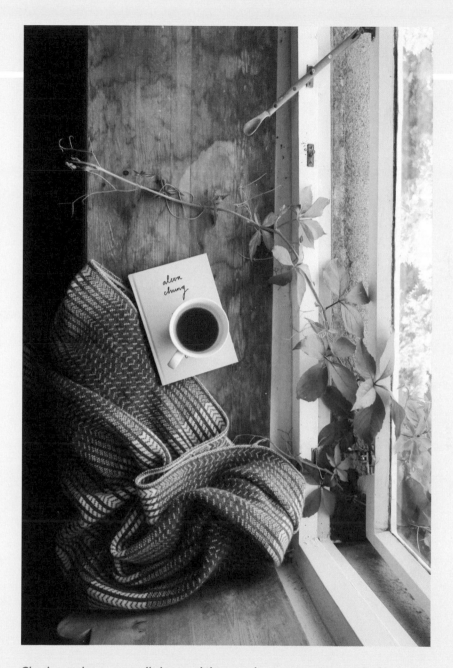

Check your images are all clear, and then put down your camera and take a break. I often find it best to edit with fresh eyes, so read through the following pages on editing and come back to these images a little later.

BEFORE AFTER

EDITING ON YOUR PHONE

The process of editing on a phone has recently evolved to the point where it almost parallels desktop editing. The Lightroom app is wonderful for basic corrections and colour grading, and Photoshop Mix is great for adding layers and special effects such as clouds, birds or anything your imagination can conjure. Phone editing gives you a better indication of how the colours will appear on your feed, while transferring desktop edits can lead to a change in colour when viewed on a phone screen.

@monalogue, UK

Editing for Instagram on my iPhone is quick, easy and fun, and I get to preview the images exactly as they'll be seen – on a small screen in the palm of the hand. Phone editing apps tend to be geared towards the Instagram style of editing, too, offering moody, vintage presets and quick-fix tools for the casual photographer who doesn't want the trouble of learning Photoshop or Lightroom.

Best of all, editing on my phone means I can shoot, edit and share in real time from pretty much anywhere in the world. Once you've experienced the freedom of working on the go like this, it becomes increasingly hard to justify dragging your bulky laptop with you on trips, holidays and photo shoots!

There are a range of simple ways to get your images from an external camera to your phone if you're shooting that way. If your camera is wifi or Bluetooth enabled, it's simple to just pass them across. Failing that, take a look at the tips on page 96 for other ways to easily move images across.

The Instagram app comes with its own simple editing tools, but there's a whole spectrum of fun to explore in your app store, too.

There is an overview of the editing apps I find myself using and recommending most often on page 102. It's fine to just choose one or two that work for you and stick with those – there tends to be a lot of overlap between functions in any case, so it's mainly about finding the one that feels most comfortable and intuitive, and the best fit to the way you like to work.

I'm aware that no sooner will I put these down in writing than the market and technology will

change, so by all means do your own research, too. These are my favourites that have been a part of my repertoire for the last four or more years, and that I have faith will continue to move with the times and stay useful in future.

BRIGHT & CLEAR

Before beginning any editing on your phone, first make sure that your screen is clean, your brightness setting is turned up and you don't have any night-mode or accessibility filters changing the colour of your display.

START WITH THE FIXES

If there's anything 'wrong' with the image that you'd like to fix, work on this first. I usually go in and straighten any perspective issues and crop, before moving on to any other tweaks.

PAY ATTENTION TO YOUR WHITE BALANCE

Getting the 'temperature' of your light as natural as possible before you apply any presets or filters is key to a consistent result and a harmonized style to your editing. Artificial light and sunlight on a bright day tend to be at the more yellow or 'warm' end of the scale. Natural daylight filtered through clouds is more blue or 'cool' – hence those blue-coloured daylight simulation lightbulbs you can buy.

DON'T OVERDO IT

Too much of any tool or setting can nudge an edit over into jarring, and detract from instead of enhancing your finished image. Look for options in your favourite app to dial down the strength of presets, and use a light hand when editing.

DON'T UNDERDO IT EITHER

Sometimes people think it is 'cheating' or somehow less honest if they do anything but post their images directly from the camera, unchanged. The truth is, post-production is as much a part of the process of modern photography as taking the photo to begin with! Most image presets came about from 'film-emulation' technology, with digital photographers trying to recreate the variety in tones and finish that different types of film could deliver. With digital photography, we simply make this decision after shooting, instead of before. In apps like Instagram we tend to tune into processed imagery, and anyone sharing an unedited photograph can find they look a little underwhelming and 'unfinished' in this context.

FIND YOUR FAVOURITE PRESETS

While I don't think you have to be loyal to just one preset, or even one app, it pays to know your old favourites and roughly what sort of result you can expect when using them.

ADD YOUR FILTER LAST

For predictable and reliable results, it works best to work on all your edits and tweaks to the basic image, then add your preset or filter as a final step. Sometimes there'll still be a final adjustment or two afterwards, but it's much easier to see what a preset changes when you're working with a clear baseline image underneath. This is also true if you're going to do any object removal or digital manipulation techniques. Adding your preset last will help harmonize the effect and keep things looking as natural as possible.

VSCO

Free, with additional presets available at a small cost.
Available on iPhone & Android.

My first choice for smartphone editing, VSCO offers a range of purchasable preset packs comprising different moods, styles and aesthetics. Look out for occasional limited edition presets, and special offer periods where you can get the whole range at a discounted rate. The editing tools are all free and are solid and reliable, but some users complain it's a little bit counter-intuitive and tricky to navigate at first.

GREAT FOR: Any general post-production fixes. Adding a sense of mood and ambience to your imagery. Generally preferred by people who favour darker, shadow-filled or more muted imagery.

A Color Story

Free, with additional options and presets at a cost.
Available on iPhone & Android.

This app was developed by the blogging duo at A Beautiful Mess specifically for editing images for Instagram. A Color Story (note the American spelling) is similar to VSCO, but is generally preferred by creators with a brighter, more colourful aesthetic. There are in-app purchases available for additional presets and tools and ways to tweak your imagery. Includes curves, bokeh (out-of-focus aesthetic) and other fun features.

GREAT FOR: Any general post-production. A bright, colourful aesthetic. Creative edits.

Photoshop Lightroom

Available on iPhone & Android.

From the team behind the gold-standard desktop software Adobe Photoshop and Lightroom, this app aims to offer the most popular editing tools in one app. It is not the same as the desktop version of either program, but regular users love being able to share presets across both versions and easily transfer images using Creative Cloud.

GREAT FOR: Applying presets you have stored on your desktop-editing software.

Snapseed

Free. Available on iPhone & Android.

Snapseed breaks the mould in offering editing tools and options the other apps do not. It's also completely free, and always worth having on your phone for any especially tricky fixes. The presets aren't my favourite, but it's easy enough to fix a photo in Snapseed then quickly apply a filter in VSCO or one of the other apps above.

Great for: General post processing, tricky photo fixes and more complex edits. The brush tool for exposure, saturation and dodge/burn is especially brilliant.

TouchRetouch

Available on iPhone & Android.

This cheap and nifty little app works to remove unwanted lines or objects from any image on your phone. A little like using the Photoshop clone and blemish tools, but more intuitive and less labour intensive, with surprisingly convincing, quick results.

GREAT FOR: Removing pylons, telephone wires or background strangers from your shots.

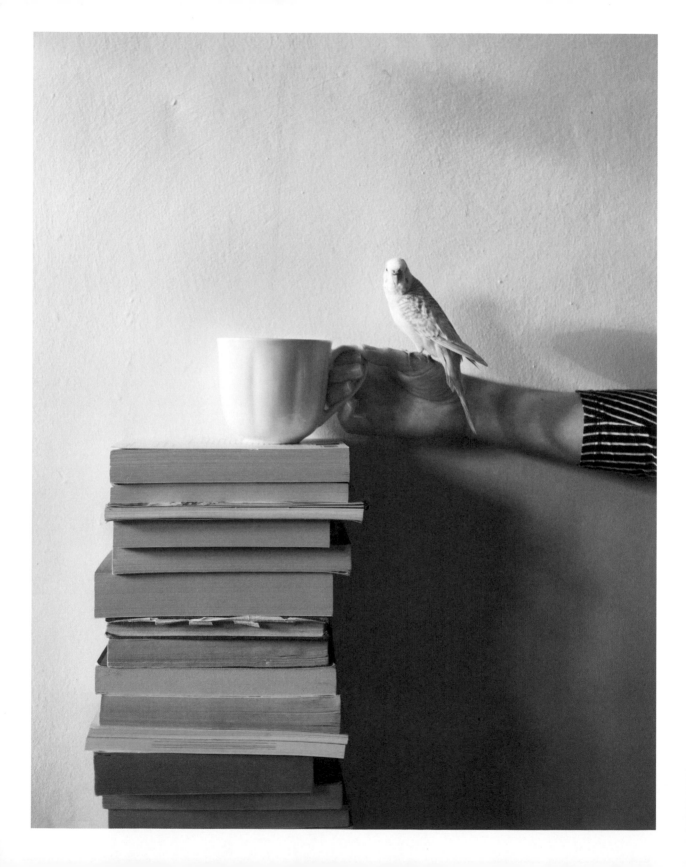

A STEADY FLOW OF INSPIRATION

Inevitably with any creative adventure, there are times when inspiration seems to abandon us. To keep up the pace with your visual storytelling, and to never feel like there's nothing to shoot, it can be fun to introduce a few projects or running themes within your work.

THE POWER OF PROJECTS

I began my Instagram journey with a commitment to take and share a photograph a day for a year – a 365 project, as they're sometimes called. A photo project can take any form – you could create scenes from your favourite movies, recipes from your favourite books, snap romantic graffiti wherever you travel, or simply take a series of self-portraits over the course of a year. Having a project gives us a reason to keep creating, and often a bit of a push to pick up the camera and keep forging ahead.

VARIATIONS ON A THEME

If one particular scene has worked well for you and perhaps with your audience, it can be fun to think of ways to keep reinventing it into an ongoing series. Taking the same image but changing one key element keeps it fresh, and begins to build a collection of photographs that can sit together to say something more. Look back through your recent work and see if there's anything you could rework in a new dimension.

GRADUAL CHANGE

Sometimes the familiar things in our lives can tell a story over time, like the changing view out of my window, or the way a newborn baby grows month by month to dwarf its first cuddly toy. Repeating the same image regularly can be a great way to document gradual change and the incremental passage of time.

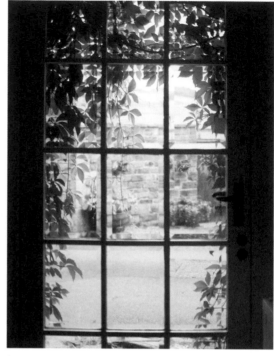

HUMOUR

We can take our photography seriously without always having to be serious. Some of the best Instagram accounts can have us crying with laughter – from parody images, recreations of impossible celebrity photos, to yoga-practising Barbie dolls, images can be packed with humour and are undoubtedly as fun to consume as they are to create.

Feeling tired and a little burned out one year, I took a cardboard Luke Skywalker cut-out on a series of romantic 'dates' for some Instagram snaps. The ridiculous joy of taking an orange-clad Jedi on the London Underground, to windy Northumberland beaches and out to lunch with friends was such a welcome antidote to all the time I'd spent overthinking my own photography, and I eventually wound up meeting the actor who played him to take the final shot in the series!

WHP

Every weekend, Instagram prompts users to get creative with a '#whp' or 'weekend hashtag project', and features their favourite responses on their own huge account. The theme has usually been announced by Saturday morning, wherever you are in the world, and you can find it by checking the latest posts on their @instagram account. Previous themes have included things like 'hidden', 'light', 'movement' and 'love', and browsing the entries under that week's hashtag is a great way to find new people to follow and to get inspired.

Having the constraints of a topic and a timescale – all entries must be uploaded by Monday to be considered for that week's selection – can be a great boost to creativity and really spur us into action to try something different and new.

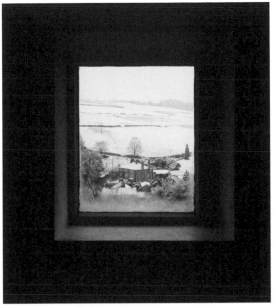

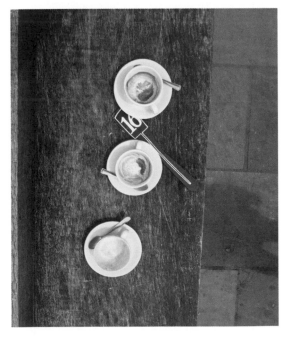

Recreate and reimagine

Go back to the moodboard of inspiration images we put together on page 36 and choose a favourite scene. We're going to have a go at recreating and reimagining this into something of our own. It can feel odd, using someone else's work as a jumping-off point, but it's a brilliant way to learn. Just like when learning to paint or play piano, we begin by imitating the great masters, so we can discover so much about our own technique and skill by walking in the shoes of someone whose work we admire.

Take a good look at the image you'll be recreating.

- *What do you love about it?*
- *What elements do you want to keep?*
- *What direction is the light coming from, and what kind of light is it?*
- *How is the composition formed?*
- *What elements of this will you use in your recreation?*
- *What sort of editing has been done?*

Now consider what elements you'd like to change. It's easy enough to create a carbon copy without changing anything, but the result is often unsatisfying – it doesn't really reflect our vision, and often compares poorly to the inspiration image we were working from.

Instead, look at the objects, subjects and locations, and think about how you can make them your own. Perhaps your inspiration image is taken against a sunset beach sky, but yours will be of a cityscape at sunset because of where you live. Maybe you love an image of someone's coffee and current knitting project, but can switch in your morning tea and calligraphy practice to make it your own.

Set up the scene and experiment with taking the picture. Expect it to be tricky – the light, the shadows, the angles, your own inner critic chattering a

steady stream of abuse. Ignore that voice, keep checking back with your inspo image, and continue adjusting, reflecting and trying again.

The aim is not to wind up with a perfect recreation, of course, but to figure all of this out. Where were they stood in order to get that perfect symmetry? How had they wedged their cup to get it to sit like that? These are the little lessons we learn along the way as visual storytellers, and trying on other people's photography like this is a great shortcut to working it all out.

If you end up loving what you created, go ahead and share it online. It's good etiquette to share your inspiration image, too, tagging the creator to give credit where it is due.

Hashtag your image uploads with **#HashtagAuthenticCreation** and tag me, too, so I can swing by and cheer you along, and so others working through this process can see how you got on!

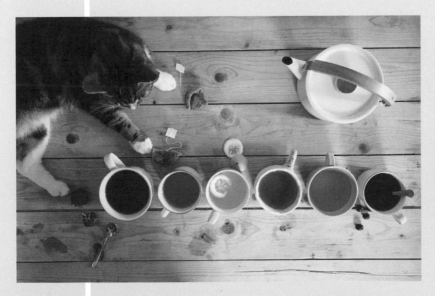

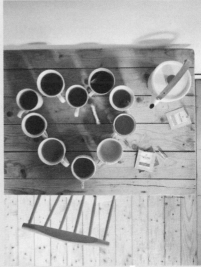

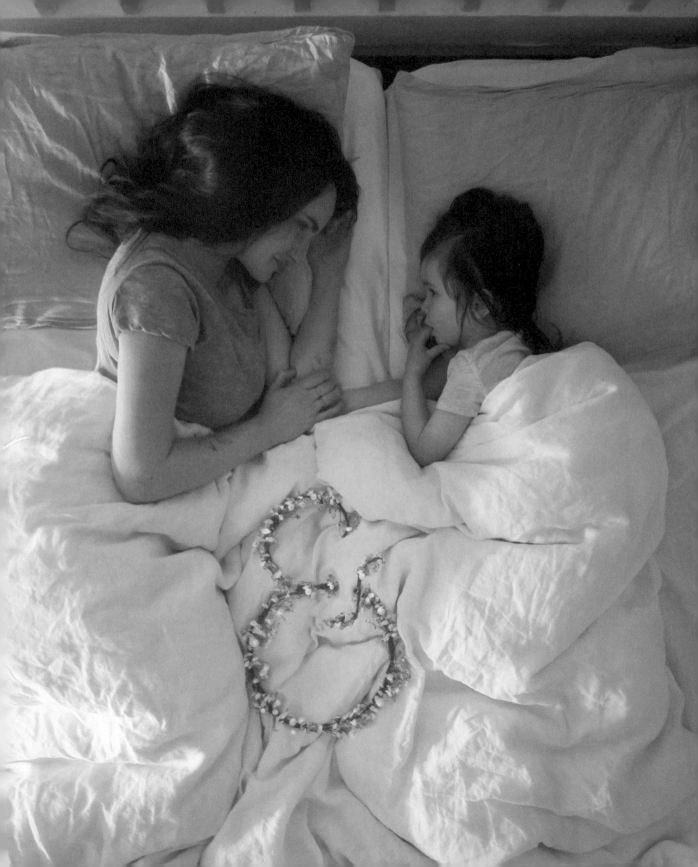

ARCHIVING YOUR LIFE

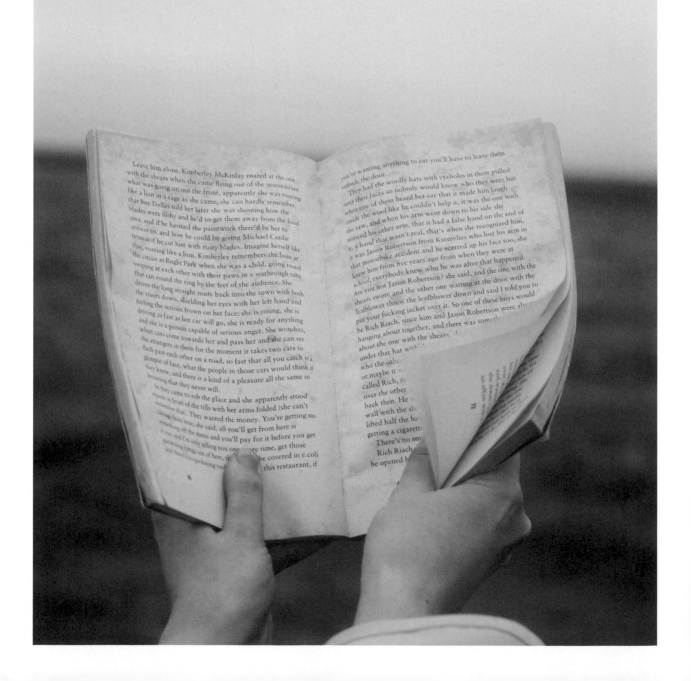

IT DOESN'T HAVE TO BE DISNEYLAND

In the tapestry of childhood, what stands out is not the splashy, blow-out trips to Disneyland,
but the common threads that run throughout and repeat; the family dinners, nature walks,
reading together at bedtime, Saturday morning pancakes…

Kim John Payne

Whether or not you have kids in your life, there's something we can all relate to in these words. The idea of life being a tapestry woven together by common threads, some repeated, some unique, one or two occasionally shot through with gold.

That's not to say, of course, that those flashy trips to Disneyland don't have their place. But when we look back, for most of us it still comes down to the gentle details: the plastic mouse ears that we insisted on buying in the colourful gift shop. The wails at the ice cream cone that was dropped on the ground.

Often, when talking about Instagram with clients or friends, they'll tell me that they've run out of ideas. They've no more inspiration; they're too busy to think up new shots all the time. Or perhaps they have to go away travelling, and the careful routine of photography that they've made for themself seems to all come unravelled on the road.

Life, of course, will do this. New places, seasons, life events and trends; family commitments, work upheavals, special occasions, testing times. They'll come along and try to blow us off path, and make it hard to see anything worth capturing.

Our creative practice can be the most wonderful tool in stressful or difficult times, but if we're going to enjoy it, we have to let go of the voice of perfection, of how we think it should be. We have to tune out what everyone else is doing, and dig into the magic of our own story to tell.

In this chapter, I've shared some tips for digging out the wonder in the everyday world around you. We don't need a perfect home, a perfect wardrobe, a perfect life. Whatever our life looks like, it's our own Magic Kingdom, just waiting to be shared.

A NOTE ON HASHTAGS

All of the Instagram hashtags I've shared in this chapter were full of inspiring and brilliant images at the time of writing. Hashtags can evolve or be taken over by spam accounts for a while, so please click with caution and forget any suggestions if they're less appropriate by the time you come to look them up! Better yet, cross mine out and add your own to the list. Writing in books is totally acceptable. I share fresh hashtag suggestions every month in my free newsletter. Join the list at **meandorla.co.uk** to stay updated too!

CRAFT & MAKING

Sometimes, when there's truly nothing worth photographing, we have to make our own beauty.

Art and craft activities are the perfect route to this. Whether it's potato-printing wrapping paper with the kids or weaving a delicate spring wreath by yourself to the sound of the kitchen radio, making and doing is a gentle, calming way to bring something new and conveniently 'Instagram worthy' into your day.

Plus, of course, these activities bring us joy and precious headspace in their own right. Whether you're a hobby crafter, an artist or a pro, documenting your process and results allows us to record our progress, share our techniques and bring a whole new facet of reflection and understanding to our work.

When photographing making, don't neglect to show the work in progress. Sometimes just the tools and materials laid out can set the tone of possibility and capture the quiet enjoyment of having half an hour ahead of you to work with your hands.

Be sure to capture the texture and mess of the midway point – let us see if you're a tidy, organized worker or, like me, seem to endlessly spread out across a space. These tactile and relatable details all draw your viewer in and add nuance to your visual story.

Don't be afraid to document the times when things go wrong as well as right! There's a temptation to whitewash our world and only photograph the best bits, but the messes and mistakes in whatever we're doing are often where the really juicy lessons lie.

When you're done, consider styling the finished result to flaunt it in all its glory. You can easily end up with ten or so great images from a single craft activity, which you can then space out on your feed, share to Stories, post on blog posts or perhaps use to form a simple tutorial. If there's a particular craft you enjoy, don't be afraid to repeat it with different variables to create a series, for example floral wreaths or loaf cakes.

HASHTAGS TO EXPLORE
#makersgonnamake #wipsandblooms
#slowliving_create *('WIP' stands for 'work in progress')*

'Instagram is at the same time a daily diary of my thinking and making process, an historical record of my improvement at my craft and the main way I share my work with my customers.

It allows me to be both highly personal and commercially viable. It's made me a better photographer and writer, and helped to connect with people I'd never have known about without it.'

@jonosmart, Scotland

GETTING YOUR HANDS IN SHOT

There are a number of ways to get both hands into your shot that don't require too much kit or preparation.

To keep it really simple, just switch your phone to self-timer mode, slide the phone between your teeth and bite down like you would on a cookie. Hit the shutter release then quickly slip both hands back in frame. It takes a little practice and looks completely hilarious in public, but it works a charm with no extra equipment required!

Alternatively, set up a boom arm over your workstation using a long plank or stick with a heavy counterweight at the opposite end.

Attach your phone using masking tape or simply by balancing it with the camera peeking past the edge of your plank.

I've also had success attaching a twisty-legged 'gorilla tripod' to a hook in the ceiling.

If you do these shots regularly, consider buying a dedicated tripod with an arm.

Obviously, be extra careful when playing with your phone at a height and do your best not to drop it. I can accept no liability for injuries sustained while balancing on one leg, trying to tape your phone to the ceiling for an admittedly stellar Insta shot.

FOOD & INGREDIENTS

Have you ever seen a photograph of another family's Sunday roast dinner or Christmas meal? Often they look wildly unfamiliar, despite being assembled from the same essential parts. Food is deeply personal. It's full of ritual, history, social rules and constructs and a fair old heap of irrational morality, too.

For this reason sharing food can feel vulnerable and intimate – and can also foster a real sense of connection, too. It also has stacks of that 'thumb-stopping' click appeal when done well – just pay attention to how much more you're attracted to images of food on Instagram before lunch versus afterwards!

Here are some things to consider when presenting food in your photography:

Share the history. The meals we regularly prepare and share come to feel familiar to us, like well-worn shoes – the smell of my grandmother's recipes cooking always feeling like a sense of home. I weave this into my images by using her old baking trays, or including her handwritten recipe book.

Presentation counts. There's a reason top chefs in restaurants worry so much about the presentation of their food – and did so, even before the days

of Instagram! While for regular meals we're mostly happy to just heap it onto a plate, when someone cannot smell it, touch it, taste it or know how carefully it was made, they're left relying solely on the visual elements to decide whether a dish is at all appetizing or not. Think about how things sit together on a plate, where the negative space is, how the colours and shapes look together. Sound familiar? It's essentially all the same things we look at when creating a composition – except this time, the frame we're working within is the plate.

The wider scene. What surface is the plate on? What else is on the table? Are there other people sharing the meal? Can we see their plates and glasses too? Or, perhaps this is food in the hand, or food in preparation. Don't miss out the essential clues around the food that give it greater context and significance.

HASHTAGS TO EXPLORE
#MyCommonTable #foodstylingclub #myopenkitchen #tablesituation

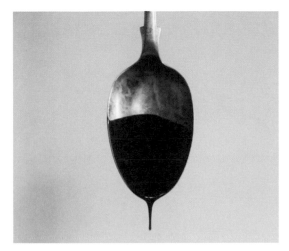

'Food cooked in the kitchen and shared around the table is a five senses affair – sounds, smells, textures, tastes, colours – and even a sixth, emotion. When you're styling and photographing food for social media you only have one sense to work with: sight. Your job is to creatively use that one sense to invoke the others. I've found the best way to convey other senses in my food photography is to use props that create a mood. Create life-like mess-like drips and crumbs that convey textures and tastes, incorporate action like steam or hands when appropriate, and (most importantly!) shoot food in natural light, ideally diffused or indirect sunlight, because that allows its true colours to shine and entice the viewer into both the moment and the flavours.'

@local_milk, USA

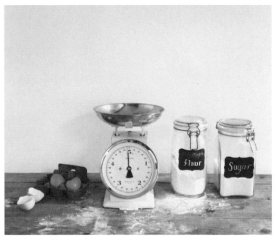

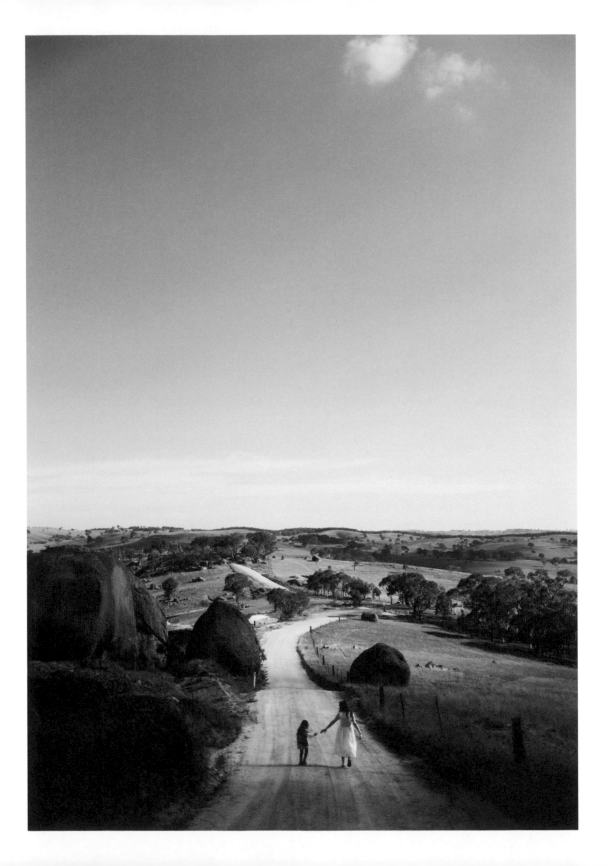

ROAD TRIPS & TRAVEL

Great travel photos can make the viewer feel like they're right there beside you. From your local town to somewhere far-flung and exotic, the small details of your travels can transport your audience on a vicarious adventure. It's one of the great joys that Instagram brings – making the global feel local.

There's often criticism of the Instagram travel photography movement for taking people 'out of the moment' – leading people to visit destinations purely based on a photograph, and then spending their time gazing through a lens. While, of course, in the modern world we could all do with a little more mindfulness, I've personally always found photography makes me enjoy travel more. It makes me stop and see the beauty, appreciate the smaller things. It also makes me feel perfectly happy to while away an afternoon or longer by myself, just me and my camera, without feeling out of place or conspicuous in a strange city.

In fact, when visiting somewhere for the first time I'll often start with Instagram when researching places to explore. You can always rely on the community there to have sussed out the coolest bars, cafés, beaches or monuments, and it's a great way to get an up-to-date and crowdsourced guidebook to a brand new area.

HASHTAGS TO EXPLORE
#slowtravelstories #thewanderingtourist
#traveldetails #glocal

'Travel photography became my life simply because I followed my curiosity. I picked up a camera relatively late compared to many other professional photographers, but it quickly became the most natural way for me to express myself and over time it developed into my greatest passion and then my career. It's the best way I know to share the world as I see it, and communicate what I learn as I travel to new places and meet new people. When you follow something that grabs your curiosity, it can change your life forever. For me that curiosity led me to pick up a camera and get to work on documenting the stories of people and causes around the world that need to be shared – I never asked for permission and I never looked back.'

@freyadowson, UK & Canada

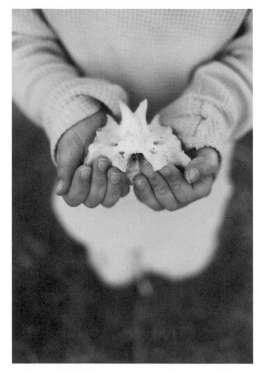

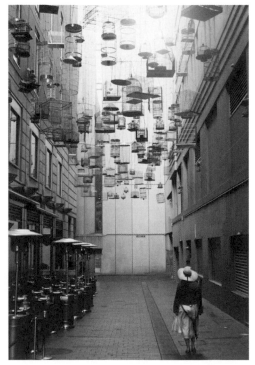

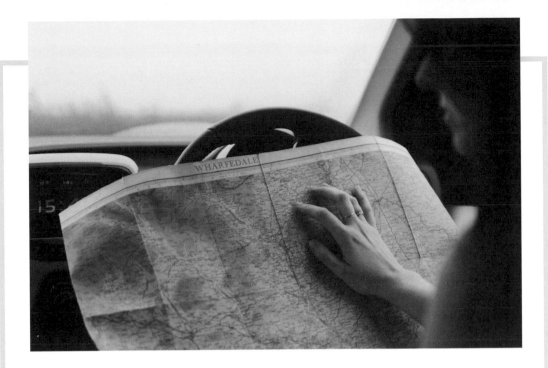

SOME HELPFUL POINTERS FOR CAPTURING YOUR TRAVELS

Keep an eye out for the small details that contrast with your normal everyday. Different letterboxes, doorbells, roadside weeds and signs in foreign languages all hold interest and story in new places.

Give your adventure a beginning, middle and end. Share your packing on Instagram Stories, and your arrival back home as well.

Avoid the obvious clichés. Yes, the clouds look amazing from the airplane window and I can never resist photographing them either, but like listening to other people's remembered dreams, they're often not as interesting second hand. Liven it up with an additional subject in the predictable shot – a book you recommend, a paper shape against the sky or a holiday souvenir.

Try to put your own unique spin on a familiar landscape or scene. It's easy to find those perfect Instagram views and locations online, but often they've been recreated a thousand or more times. Visit these places by all means, but check the geotag to see what others have taken there, and try to find a different take.

Be mindful that you're potentially broadcasting that your home is empty on the Internet. Make sure your home address stays anonymous online, and consider posting on a delayed schedule to protect the details of your itinerary.

Remember, people are not photo props! Always ask permission before any shot that features identifiable people at work or living their daily life. Be kind and respectful at all times.

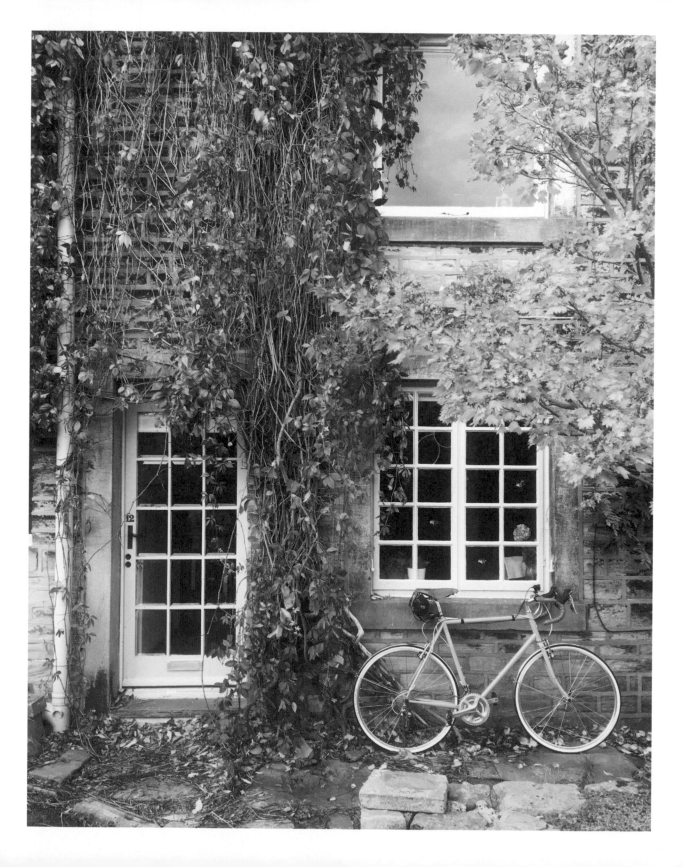

WEATHER & SEASONS

The changing weather and seasons tell a story all of their own; the exact same scene is so radically different on a snowy winter's day than on a hot summer's evening. Autumn leaves, spring blossom, summer at the beach or the first frosts of winter – wherever you are, and whatever the climate, there are always beautiful signs of nature's cycle to be captured on camera.

These seasonal moments tend to be popular online across the world. There's a certain magic in seeing the different seasons on the opposite hemisphere, or how different the same day can look on the other side of the globe.

It has a way of tying us to our roots, as well. Throughout human history, we have found ways to map the movement of the year through the natural world. It only seems right that we should bring this practice to our online sharing as well.

Below are some prompts to help get the most out of the weather around you:

Shoot the extremes. Often the more extreme ends of weather come across best in images. Brilliant blue skies, deep snow, lightning streaks or a heavy, sudden downpour.

Look indoors. There are always tell-tale signs of the season, even indoors. The clothing and accessories we use in different weather are full of nostalgia and narrative. Muddy boots by the door; a bright umbrella, wet from the rain; snow-dusted mittens, a folded picnic blanket streaked with suncream and sand.

Capture nature's best. No matter what the season, there are always quiet little clues to be found in parks and gardens. Whether it's the first sprigs of green pushing up through the snow or a carpet of magnolia petals on the pavement, look for the special, surprising moments when you first realize change is in the air.

Create a mood. We love winter and autumn scenes that conjure up a sense of cosiness and warmth, and summer snaps that seem cool and refreshing. Look for ways to juxtapose the temperature outside with the subject of your shot – ice cream in the shade in summer, thick blankets by the fire in winter.

HASHTAGS TO EXPLORE
#stillswithstories #gloomandglow
#stylingtheseasons #aseasonalshift

'I love the contrast of the seasons. From moody January to the bright and airy June. It's not just dark in Scandinavia, but there will always be shadows, and that's what I love to work with. On earth there is no heaven, but sometimes, when I look carefully, there are pieces of it.'

@poppyloveyou, Denmark

OCCASIONS & CELEBRATIONS

Those red-letter days when we tend to reach for the camera form the staple of most family photograph albums. We can use our skills as visual storytellers to capture more of the mood and moments of these days, and create a mini time capsule to look back on whenever we choose. With storytelling and nostalgia already at the heart of our imagery, occasions and celebrations are a chance to crank up our emotions to full volume and really capture the heart and soul of a joyful – or in some cases difficult – occasion.

Look for the details. Everything from your guests' shoes, the choice of birthday candles, the empty chocolate-smeared cake plate – it all forms a part of the narrative.

Photograph instead of hoarding. Cards, gift-wrap, deflated balloons. I kept it all for a while after my daughter was born, then realized I could photograph the messages and sentimental details, and keep those safe in a way that didn't leave our home overflowing with paper clutter.

Record things you're liable to forget. What's the weather like outside? What were the drinks served in? What song was playing on the radio?

Mark rituals and traditions. From the snack waiting for Santa Claus to an empty place setting for a deceased relative, special occasions are often full of love, magic and meaning.

Document the people. Include their faces and figures, of course, but also look for the details – a grandparent's weathered hands carving the turkey, tiny baby feet walking in a sea of discarded giftwrap and ribbons.

Connect and share. If family occasions are difficult, or special occasions are painful for you, sharing and creating can be a welcome way to connect with people outside your home. The wonderful diversity of the Internet means you'll always find people dealing with similar experiences to help you cope – the #joinin hashtag on Twitter, for example, brings together people spending Christmas Day alone each year.

HASHTAGS TO EXPLORE
#GatheringsLikeThese #festivefaffing #tableinspiration

'It's always difficult to explain the magic that happens when a group of women gather around a beautiful setting and bring their whole selves to the table, but Instagram has given us the opportunity to share that warmth in a way that draws people in with curiosity and delight.

Capturing a gathering in full flow and sharing it is a beautiful way to hold the memories of that connection and that intimacy. It brings it back to life and allows for the magic to continue.'

@melwiggins, Northern Ireland

MAKING A HOME

Our homes and interiors are the backdrop to up to 99 per cent of our daily adventures, and say a whole heap about our tastes, thoughts and experiences.

When I first joined Instagram I was living in a small terraced house that I hated. While I was grateful for the roof over our heads, it had none of the elements that make up a home for me, and all of my days there were tinged with a bleak sense of anxiety. The big picture of my life right then was all wrong for me, so I focussed in on the small one instead. Photography gave me a way to zoom in and find the small, manageable elements that I could arrange to my choosing. With each of those little squares, I found my place in that house, and a way to feel at home with myself, instead.

It's common for interior design to be regarded as silly or trivial, yet our living spaces can have a tremendous impact on how we live and feel in the day to day. Styling a beautiful shelf, arranging a wall of magazine clippings and prints or picking a simple bunch of flowers for the kitchen table can all impact on mindset, mood and motivation in small but significant ways.

It isn't silly to care about the small things around us and the details of our home. Sometimes they're our best defence for resilience in a difficult, painful and too often ugly world.

Find the small things. A corner of a shelf, a patch of light in the kitchen, the way your kid leaves her boots on the step by the door. Especially in rented accommodation it can be hard to make a space that feels 100 per cent reflective of ourselves, but the details are always at our disposal to play with and enjoy.

Share the mess! It can be tempting to edit and tidy up just for photographs, but there's just as much magic to be found in the realities of domestic life. A crumpled unmade bed tells so many more stories than a perfectly folded and manicured one; the muddy trail of footprints my dog brings in from the yard is endlessly more entertaining than a perfectly clean floor.

Style and play. Photography and Instagram gives us the perfect excuse to get involved in our interiors and play around as often as we would like. So often we fill our homes with lovely things only to promptly ignore them from that day on. Whether it's reworking a shelf to get the perfect #shelfie, or bringing seasonal finds in from outdoors to join in with #stylingtheseasons, spending time enjoying our interiors instead of just reluctantly cleaning them once a week came as a revelation to me!

> **HASHTAGS TO EXPLORE**
> #pocketofmyhome #atmine
> #shelfiesaturday

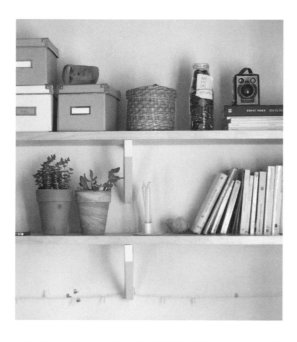

'When entering a home to photograph it, I love to take a few moments to wander through the rooms, pausing to notice the areas that the owners have poured love and attention into, and also asking for the memories behind certain pieces. These are often the corners that best share the story of the home and the life lived in it, and which create photos which accurately portray the heart of the home.'

@abbie_melle, Australia

The Internet has proven to be a natural home for beauty content, with a whole gang of fashion bloggers and make up experts sharing their work and talent online. It can feel quite intimidating, if you don't identify as one of these people – particularly when your body doesn't fit with the conventional stereotype of beauty or style.

But forget that. The Internet is a huge human soup of diversity, and by showing up and sharing our real, gorgeous, imperfect selves, we can all help to increase the representation of every body, and celebrate our style and individuality along the way.

Of course, the threat of trolling or abuse is a real concern, and I've written a little more about keeping safe and protecting yourself from this on pages 186–189. But if sharing outfits, beauty or fashion in your images appeals to you, I wish for you the joyful courage to do so without letting the naysayers and bullies of the world being able to drown out your creative voice.

Capture outfits in a whole range of ways.
From laid out flat on the bed before dressing, to hanging on a wardrobe, to a selfie or portrait of you wearing it in action.

Add hats. They make a great addition to any portrait, particularly of a figure against a landscape. Something large and architectural stands out and adds character and interest to the person in a wider scene.

Show accessories in context. A watch on your arm, a handbag slung over the back of a chair – or styled into a flatlay or scene.

Wear something that reflects the mood or atmosphere you're trying to capture. The colours, texture and weight of the fabric, silhouette and positioning of clothes all change the mood and meaning in portrait photography.

Don't always stay static. Video works brilliantly to showcase the motion in outfits and clothes. One of my favourite quotes from singer Ani DiFranco says, *'I don't take good pictures because I have the kind of beauty that moves.'*

Have fun with costumes and fancy dress. It's fun to play, whether it's creating a photo scene or simply a snap before you dash out the door to a party. Have fun dressing up your whole family or friendship group in co-ordinating outfits, or choose contrasting clothes to highlight the differences between two people in one frame.

HASHTAGS TO EXPLORE
#midsizestyle #mystylediary
#ootdflatlay *('ootd' is short for outfit of the day)*

'If you're not normally pouty in snaps then don't try and force it. I always smile, twirl about and aim to show a bit of my eccentric personality. Keep reviewing the photos to see what you're happy with (it also helps if you have a patient photographer who will keep you calm). If you get really stuck, then try and research a few poses beforehand and save them to an Instagram Collection. Props are always useful, too, so experiment with flowers or holding a colourful magazine.'

@iamkristabel, UK

FAMILY & PETS

There was recently a news story about a box of old photo slides found at a second hand sale. When the equipment was found to develop them, a stack of family photographs from the early 1900s were revealed – strangers, living their daily lives, yet somehow still relatable and compelling. Portraits of those closest to us offer the chance to catch something different – an unguarded, natural take that is entirely different to what we see in studio photos or staged professional shots. This distinction creates an image with so much depth and affection that, even a hundred years on, it can leap out of the frame and tell its story.

Remember the mundane. Include everyday moments that you most associate with each person – shining their shoes, grinding their morning coffee, styling their hair, washing their car.

Capture a range of expressions. I'm forever grateful to my mother-in-law for her tip to photograph my baby as she cried as well as when she smiled. When you're living with a newborn it's hard to imagine you'll ever want to see a tearful face again, but when they grow big and it's long forgotten, that scrumpled, red little face is a ticket back to those early, desperate and magical days. A serious-faced partner at work; the neutral expression of a grandparent as they sip their tea. We're used to pasting on false smiles for photos, but our natural expressions are capable of so much more.

Pets are family too, and always a popular feature on social media. There are apps available that will play a novelty sound before shutter release to capture your pets' attention and encourage them to look at the camera – these work well on young children or anyone feeling camera shy, too.

Be mindful whenever you share images of other people online. This goes especially for children or vulnerable adults. See pages 186–189 for more notes on online safety and deciding what you want to share.

HASHTAGS TO EXPLORE
#thehonestlens #the_sugar_jar
#hellostoryteller

'I try to capture my children as naturally as possible.

As Instagram is a platform where everybody can see your kids' photos, I really try to be cautious, not to expose them too much. So I often shoot from above, crop some parts of the body, take photos of them from the back. I really want my photos to suggest things rather than obviously showing them. It is a more subtle way to tell a story.'

@cecilemoli, France

LANDSCAPES & NATURE

It's easy to take the landscapes we see everyday – whether an urban skyline or something more rural and empty – for granted. When I first moved out of the city to the dramatic green hills of Yorkshire I vowed to never stop appreciating the view outside my window, but some days I do still love to get lost in the otherworldly landscapes of far-flung destinations on my Instagram feed.

The brilliant global connectivity of Instagram means there are always fresh eyes to see our familiar, domestic terrain anew, and to offer the same experience in return.

Capture the scale of a landscape. Include small details, like distant houses or a figure in the foreground to provide a contrast in size.

Pay special attention to your angles and lines. When shooting large-scale landscapes, make sure your horizon is perfectly straight. (See pages 54–67 for more composition tips.) Shoot from a few different angles – standing, crouching, moving side to side – to compose with different amounts of foreground, background and sky.

Consider the orientation of your photo. Landscapes are traditionally shot, unsurprisingly, in landscape, but a portrait capture fills more of the screen online.

Aim to tell a story with your landscapes. Wherever possible remember our motto of '*moments, not things*'. Your framing, the weather, colours, mood and details can all make a landscape feel like a living moment to draw your viewers in – just as the old masters in landscape painting included figures, cattle and homes.

Capture small details of nature around you. Sometimes our landscape can simply be your view across the grass at the park, or the way the flowers tumble down the wall.

> **HASHTAGS TO EXPLORE**
> #exploretocreate #folkscenery
> #beboundless

'We post on Instagram so other people can see our pictures. It's important to think about what those people see. What do you want to say with your photographs? What story do you want to tell? What colours will convey that mood? Really look at your surroundings, visualize how you want your picture to look and do what you need to do to achieve that. It might mean moving position, waiting for the light to change, but it could be the difference between a good photo and a great one.'

@theslowtraveler, UK

WHIMSY & MAGIC

We've talked a lot about capturing the world around you, but your inner world has a place in all of this too! If you're finding yourself imagining impossible scenes or would like to bring your daydreams into the frame, you'll find Instagram is a natural home for whimsical and creative content, where it can really stand out.

Start simple. Experiment with props, mirrors and unexpected compositions with an element of magic. Try substituting an everyday item for something different, like covering your hair with flower petals or filling a bathtub with milk.

Play with forced perspective. Moving objects nearer or further away from the camera to make them appear larger or smaller than they really are (like in that typical 'tourist holding up the Tower of Pisa' photo!). You might need a friend to help you capture both elements at once for this, or some people find it easier to take the two images separately and combine them digitally for the finished scene.

For added help, look into the world of digital manipulation. Adobe's Photoshop is the gold standard for this kind of editing, but there are also a range of more affordable and beginner-friendly apps such as PicsArt that you can use on your phone.

Shop around for inspiration. Sites like Pinterest, Tumblr, the PicsArt app photo stream as well as your favourite magazines or children's books can all spark ideas and inspiration.

Credit where it's due. Remember to credit your inspiration whenever possible, and never use copyrighted imagery in your own compositions without a license or consent. There's a range of free-to-use imagery available online, and Google image search makes it possible to see only royalty-free results.

> **HASHTAGS TO EXPLORE**
> #scenesfromtheceiling #mymagicalmirror #make_more_magic

'For me, Instagram is all about creating images that pull people in, that make them look again, want to see more, or feel connected to it. I want to stop people from scrolling and be intrigued enough to engage with the image. I want people to feel transported for a while, laugh for a while, be outraged for a while or just be stuck in a story just enough to forget for a while. I think that's what a good Instagram image does; it gives you a break even if it's just for a moment.'

@bookishbronte, UK

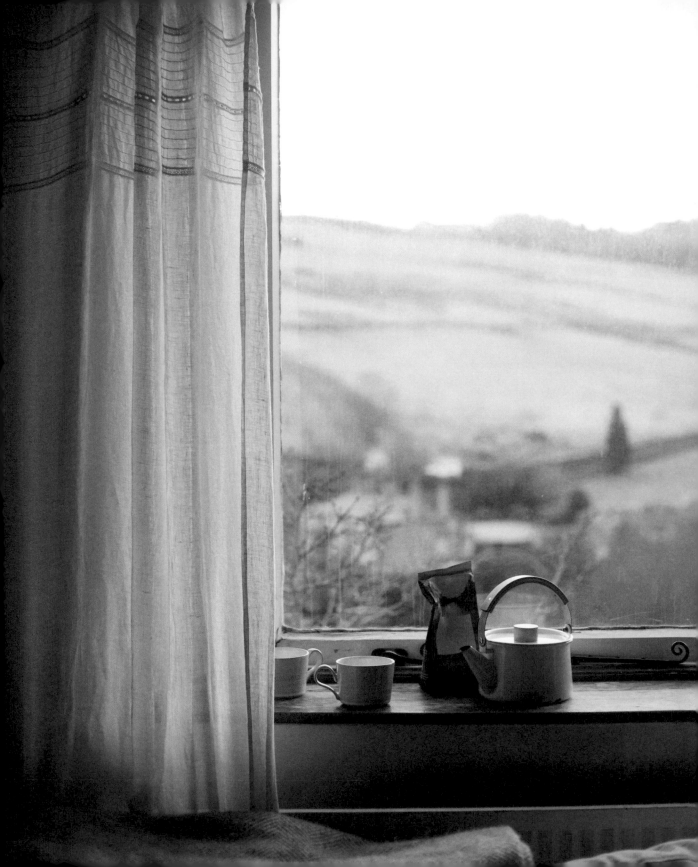

SHARING YOUR WORLD

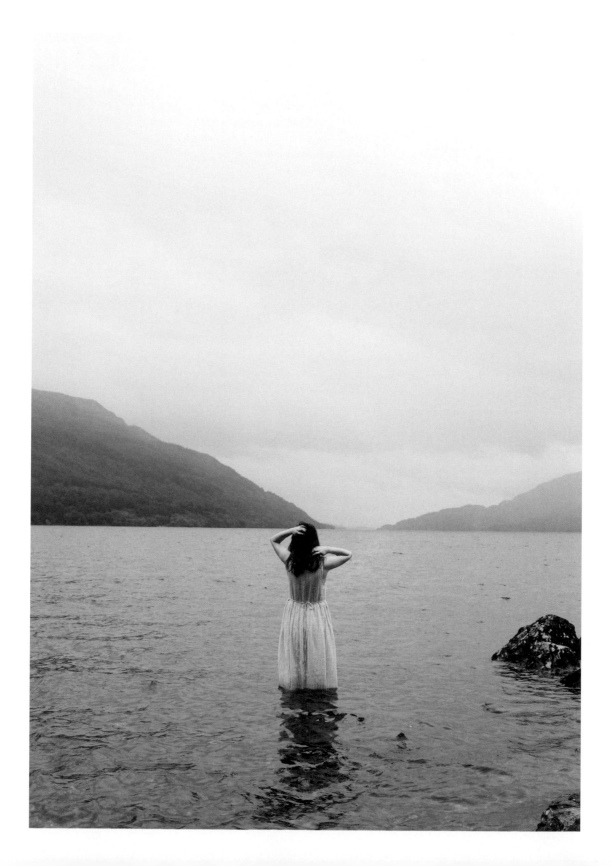

A PERSONAL EXHIBITION

People will forget what you said, people will forget what you did, but people will
never forget how you made them feel.

Maya Angelou

Your Instagram gallery is just that – a hand-curated exhibition of your life in pictures and video. As the curator and designer of this gallery, you get to choose how it's presented to the world.

What is your exhibition about? How do you want it to make people feel?

If you've ever typed your name into Google, you've probably spotted your Instagram page in the top couple of search results. As the platform expands to offer increasingly more content options – Stories, Story highlights and now IGTV – our Instagram profile acts like our go-to Internet homepage – an unintentional business card to the masses. With everyone from prospective dates to our future employers potentially giving it the eye, there's value in crafting something that really does us justice.

That can feel a little counter-intuitive given the name and nature of the app. Instagram began as a place to share 'instant' moments, using only our camera phones and the simple filters offered in-app.

Now, most of us will shoot in advance. We hook up to DSLR cameras, use more sophisticated editing software and consider carefully whether something is worthy of taking a space on our 'grid'. All of these changes can be directly traced to people realizing the huge power and potential the

app provides – with so much at stake, creators have had to continually up their game.

It can seem daunting, at first, to plunge into an arena with so many people already ahead. How do we know what's worth sharing? Is it really possible to learn on the go? How do we keep the space to experiment and to please our own creative impulses when it feels like the world might be waiting to see us fail? Below is my advice for when you feel overwhelmed in the face of public scrutiny.

YOU'RE NOT BEHIND

You're not in competition and it isn't a race. Think of your creative journey as a winding path or a toboggan run down a mountainside. It doesn't matter how fast you get to the end: you're the only one on your path, and the finish line will still be waiting for you.

LISTEN TO YOUR AUDIENCE

Did someone tell you that your comment or caption made their day? Did a Story you shared really resonate, and get five times as many responses as usual? By tuning in to our audience we're better able to see the value our work is bringing to the platform, and how we can lean into that more.

POST YOUR BEST

Wherever you are on your photographic journey, push yourself to share your very favourite work on your gallery. If you're very new to photography, your best work might still feel a bit basic or disappointing to your own eyes, but it's that ability to see where you want to improve that will eventually make your work great. Keep scrutinizing, analyzing and asking yourself what you could have done better, and putting your very best work out into the world. Our best doesn't have to be perfect – it's just about being happy with what we've created, and sharing from a place of joy.

EMBRACE THE PUBLIC LEARNING CURVE

Scroll back far enough on anyone's Instagram feed and you can see anyone's progress unfold. Head to my account at @me_and_orla and you can see the gradual evolution of my style, voice and skills, from shoddy, blurry iPhone snaps to the work I'm creating today. It can feel scary to put out our work to an audience when we don't truly feel ready – but the rewards are the greatest when we do. Instagram is largely a safe and nurturing space in which to put ourselves out there, and all that feedback and connection is the best motivation to keep pushing ahead. Leaning into the public learning curve and sharing your journey of discovery helps forge connections and allows people to invest in you and what you're trying to do, right from the word go.

LET GO OF THE FEAR OF JUDGEMENT

Stop trying to appease the imaginary negative reactions inside of your head. It's understandable, of course – holding up our creative ambitions to a sea of strangers is incredibly vulnerable, and it's normal to feel afraid. But often it's not the strangers, but the people we know best – friends, family, neighbours and colleagues – who we're most concerned about receiving that judgement from. It's the folks who've got us labelled as one thing, who we suspect might not have room to let us be anything else.

Notice how this judgement is largely imagined – is there any actual evidence that they think this way? Have they said anything to prove it? If they have, remember that negativity like this is almost always about them, and rarely actually about us. Whenever we get jealous, bitter, resentful or scornful, it's really a sign that there's something amiss in our own private world, that we're usually trying quite desperately to ignore. If there are people in your life who make you feel this way, check whether they deserve and really need to be there. If they don't, gently let them go.

CONTINUE TO EVOLVE

In this book I've mainly focussed on Instagram, but everything we're looking at is transferable to any online platform. It was true on 'bulletin board' forums, it was true on MySpace, and it will continue to apply to whatever form social media takes in the future, too. (I'm hoping for Hologram™.)

While the apps and platforms may change, the motivation behind using them – that very human desire for connection and community – will never fade away. Master the art of communicating well through a screen and you'll be able to reach out to people no matter what changes may come.

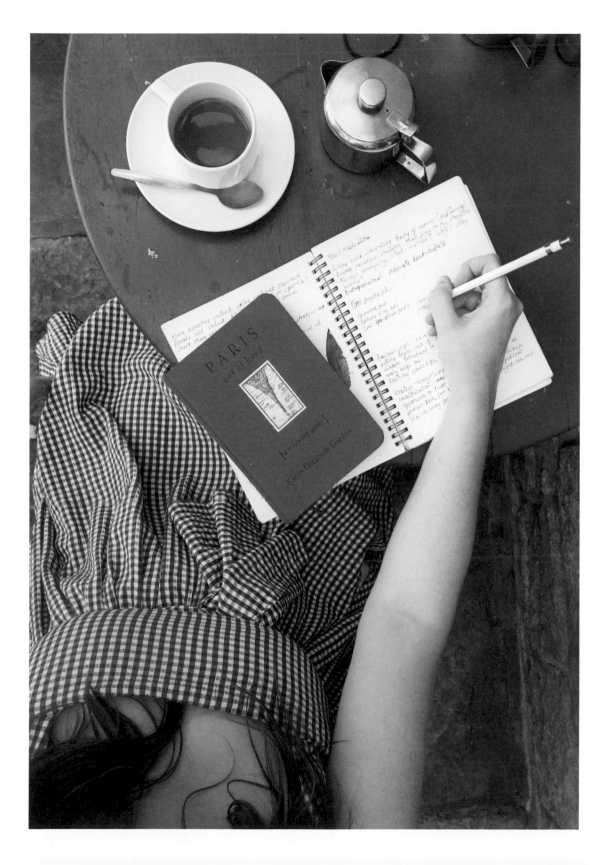

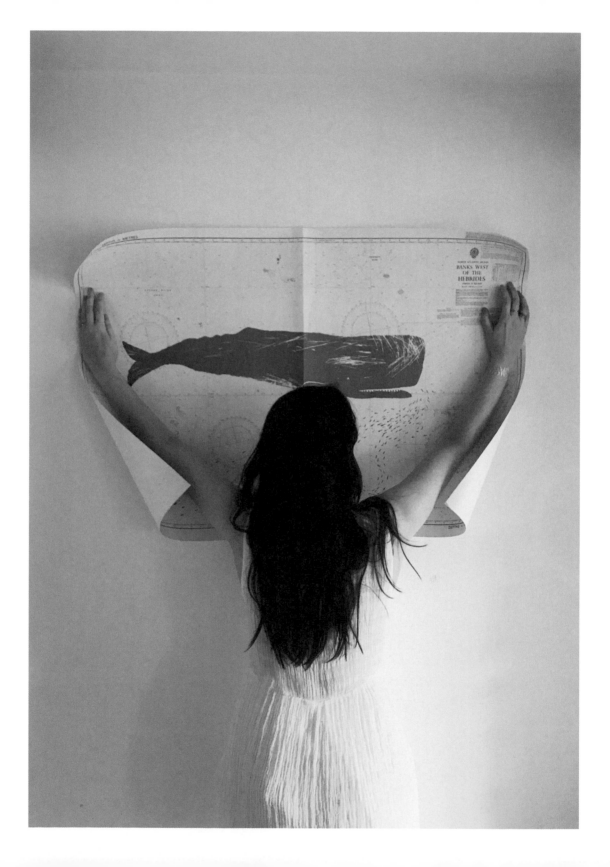

PLAN YOUR GALLERY

Great gallery pages generally equate to good follower growth. With time short and screen space precious, people are increasingly picky about who they hit that 'follow' button for, and most are looking for evidence of a cohesive, predictable level of great content in their split-second assessment of a page. The stats repeatedly show that a balanced gallery converts to new followers much more than something ad hoc or fragmented. If you frequently get visitors to your page who like individual images without hitting follow, your gallery layout is often a prime contender for the cause. That doesn't mean you have to forgo all spontaneity, though.

Here are a few pointers for curating a gallery that grabs people and draws them in, without losing the magic along the way:

USE AN APP
The easiest way to plan out your gallery is using one of the host of Instagram planning apps. Most offer options to sync with your existing Instagram gallery and then allow you to drag-and-drop new images into position to try out how they'll look. You can often draft captions and hashtags, too, allowing you to really think out your messaging and value ahead of sharing. I typically have three or four images lined up ready to post, but keep things loose and flexible enough to make room for things to change. If you take a photo that you just can't wait to share, it's easy to rearrange what's scheduled to work with the new layout instead.

Most of these apps offer the option to post directly to Instagram for you, but be vigilant whenever you're giving permissions to any third-party application. Check that they conform to Instagram's terms and conditions and, if in doubt, save the post to your camera roll and post the old-fashioned way after planning it out.

PATTERNS
A fun and effective way to plan your gallery is to try to build patterns into the flow of imagery. Sometimes this is purely about visual appeal – not wanting too many light or dark images clustered together, or photos with a similar subject or theme. Other times it's about keeping your message diverse, and making sure you offer value across all areas of your audience.

Play around with where images sit in relation to each other – not just side by side, but whether one sits on top of another, for example. A planning app comes in really handy here! A classic option to try out is a 'chequerboard' of alternating types of post – for example, light and dark images. Because the Instagram grid shows three images across, chequerboarding means no two similar posts will ever align as they move down your feed.

SAVE UP

If you shoot a lot of similar content, such as lots of landscapes on one day, try to resist the temptation to post them all right away. It's generally nicer for your audience to get to digest each image in isolation, and flooding people's homefeeds with a whole batch of similar images at once can be a little overwhelming. Rather than fill two solid rows of your gallery with similar content, consider holding some back while you mix in other work, and spreading the similar images out over a greater period of time. This allows people to appreciate each image on its own, and keeps a sense of variety and wide appeal across your whole gallery view.

HAVE FUN

Realistically, it's impractical to try to keep all these variables in check 100 per cent of the time.

I often joke with friends that they can check in on the state of my mind by seeing how balanced and matching my grid is that week! The top two or three rows of your gallery are what new visitors will judge you on – but equally, two weeks from now, those rows will be so far down that only the more dedicated scrollers will see those posts. Play around, experiment and have fun. It feels good when it all comes together, but remember it's not the end of the world when it falls apart. Just keep moving forward.

POST WHEN YOU FEEL LIKE IT

There's no rule that says you have to post daily, or that you can't post multiple times in one day. Post when you feel you have something worth sharing, and let your content dictate how active you are in any given week.

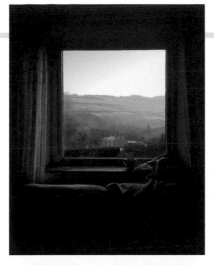
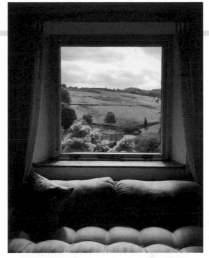
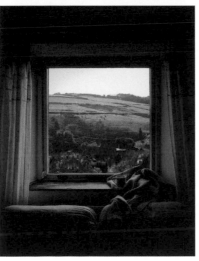
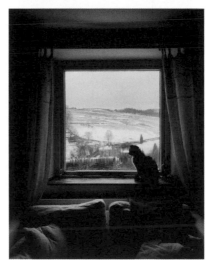

GALLERY POSTS

Within each Instagram post it is possible to share multiple images within a slider, under the same caption and gallery thumbnail. This is great for telling more of a story or grouping similar works together, but be mindful that not everyone will swipe through and look at the additional imagery. If you want an image to have maximum reach, save it for its own post, and use gallery posts for detail shots and additional angles.

CAPTIONS

Captions – the text we share below an image – are so easily underestimated. People will pour hours of effort and energy into their hashtags and image, but give only a moment's thought to what they write underneath.

Yet a caption that delivers – that makes us laugh, or cry, or look twice and leave a comment – is a way to connect with our Instagram audience in a really meaningful way. From a boost in the algorithm to building solid new friendships, the words, captions and comments are really the unsung heroes in this image-based app.

ADD VALUE

As with our imagery, a caption must be worth our readers' time. I think of this as 'giving people something they can take away'. It might be an idea – some inspiration, a recipe, a song, a styling tip or travel recommendation. It could be as simple as a feeling – a laugh, a connection, some nostalgia for a similar time in their life. Or it could be the start of a conversation – a caption that makes them feel close to you, or a prompt to share their own experience, a chance to be heard. If I use someone's recipe, I'm more likely to go back and see what else they have shared. If someone made me laugh aloud over breakfast then I'll swing by their grid the next time I'm feeling low. When we give our audience something to take away, we're building something memorable, impactful and real.

MICROBLOG

The art of logging your days in caption-sized posts – what you were wearing, thinking, feeling, doing – gives your audience a passenger-seat ride alongside on your day. Though they're short, this style of caption still needs all the style and finesse of an actual blog post – draw readers in with evocative language, beautiful details and big belly laughs.

Start to take note of the different conversations you're having in life – on Twitter, at the pub, over lunch. What topics are getting people talking? What anecdote always goes down especially well? Communication is an art form, and we practise it daily in a thousand different situations.

ENCOURAGE REPLIES

Most people know by now that adding a question encourages comments (and some good algorithm ranking!), but how often do you read one that just sounds insincere, tacked-on or dialled-in? By asking real questions, that we genuinely want to hear the answers to, we can spark conversation and really get to know our audience.

> **Asking a question in your caption and scared nobody will answer?** Like being first on the dance floor, it's always easier with your friends by your side! Share your post with friends via a direct message and ask them to come and help get the conversation started. If nobody joins in after that, then it may be you're asking the wrong questions, and need to dig into why.

Ten prompts for captivating captions

1. **What have I been feeling really charged up or emotional about lately – good or bad?**

2. **What experiences have I had lately that others can probably relate to?**

3. **What am I going through that my audience could help me with?**

4. **What topics of conversation do I always come back to with friends?**

5. **What have I been learning lately that I could share with my followers?**

6. **What questions do I have about who my followers are?** (Location, likes, age, etc)

7. **What's topical to discuss within my community?**

8. **What embarrassing anecdote is it time to share with the world?** (I got the most tremendous outpouring of replies after confessing to neglecting to lock the toilet door and getting caught mid-pee on the train…)

9. **What are you working on at the moment?**

10. **What's the story behind your photo today?**

EXAMPLE OF A CAPTION

My favourite thing to do after Christmas is to sow seeds and start planting for warmer weather. It's fairly ridiculous, I know – far too early and much too cold – but seeing those little green shoots come to life on my windowsill is like therapy to me. It's a reminder that – to steal a line from a Danish poem – 'within you there's a world of spring'. Anyone else got any rituals they use to fend off the midwinter blues?

INSTAGRAM STORIES

When Stories are used properly it's a way to foster a genuine reflection of day-to-day life, and behind the scenes of a more polished grid. I love a mix of boomerangs, talking to video, snap shots and music. When they're done well, it's hard not to feel like the person you're following is a friend: it's quite an intimate way to communicate, because the ways to execute it are so personal.

@superlativelylj, UK

Instagram Stories is a platform within a platform – a space, away from your main 'grid' of more perfect images, where you can be raw and real and relevant. Content generally lasts only 24 hours (unless you choose to showcase it for longer in 'highlights' on your profile), giving it a sense of impermanence and freedom that our main gallery can feel like it lacks.

I encourage people to think about it almost as a totally different platform – just like Instagram is different from Twitter, Tumblr, Facebook etc, Stories is distinct again. The advantage it has over these others is that it ties seamlessly with your existing Instagram account, meaning you can share followers across both these platforms, and impact one by what you do on the other.

Updating your Stories offers a different way to connect with your followers' hearts and minds. While the Insta-grid is a place for a considered, mature approach, Stories is more like the lively and messy younger sister. On Stories it is A-ok to be unconsidered, unstyled and unprepared – in fact most people I've surveyed say this is exactly what they want!

CONSIDER YOUR AUDIENCE

Increasingly we're seeing people dividing their time between Stories and the Grid unevenly. Some naturally prefer the more 'rough and ready' nature of Stories, where others are drawn more to the beautifully presented gallery page. Equally, not all users have adopted Stories into their Instagram routine yet, and we can expect that side of the app to get increasingly busy over the next couple of years. Now is a great time to get in at the 'ground level' of Stories, but if it doesn't appeal to you, it probably won't appeal to your true audience, either. (See page 179 for more on finding your audience.)

WHAT TO SHARE

As on the main gallery, value and visuals still count a lot in Stories. Anything you share should have something to offer the viewer and be presented well enough to capture their interest and deliver your message.

Editing and refined photography isn't necessary, but still apply the basic rules about getting clear, in-focus shots, making the most of the available light and considering our framing. GIFs, stylized

text, stickers, music and apps all help to create more visually appealing content, but use them to enhance your content, rather than to be the content itself. Nobody likes the backing track to drown out the vocalist (ok, except my husband, but his musical tastes are questionable!).

If you're sharing video, hold the camera as steadily as possible, and remember each slide will be limited to a maximum of 15 seconds in length. Longer videos can be split into multiple slides which will run seamlessly together, but often 15 seconds of your subject is more than enough.

The very best Stories come together to form just that: a narrative of a day, a week or a life of the person behind the lens. Consider saving up clips and images until the end of a day, to allow you to tell a more cohesive story with a beginning, a middle and end. And don't forget to enable DMs so people can reply – we're here to be sociable, after all, and communication is a two-way street.

POLLS & QUESTIONS

The option to include polls and questions stickers in Stories offer extra ways to get to know your audience and create a two-way relationship. Use polls for closed questions ('*Would you like a recipe for the muffins I shared?* Yes please / Don't tempt me') and questions for when you'd like more in-depth answers ('*What would you like me to stock more of in my store this autumn?*'). Or, host a Q&A and let your audience put their questions to you, which you can answer in a series of Stories later on.

TALKING TO CAMERA

Talking to camera is increasingly flagged as an essential skill for the next wave of social media, with vloggers and Live broadcasters building huge audiences through face-to-face conversation. But for a lot of us, especially the 'webtroverts', it can feel daunting and unnatural. If you'd like to get the hang of it, Stories is a nice place to start, as you can

To maximize views on your Stories, be sure to location tag and hashtag whenever relevant.

You can shrink these down or blend them with the background colour to make them subtle – geotagging alone has been shown to improve view count by up to 79 per cent!

'Avoid using simple "yes" or "no" answers in your poll. People like to be liked, and will probably give you the nicest answer, not the true one, as polls aren't anonymous (thank goodness). For example, if you're a product-based business looking to Stories to help with the introduction of new colours, pre-orders or similar, then maybe try 'GIVE IT TO ME NOW' vs 'NOT FOR ME ATM'. Above all, ask yourself if you really need your followers' opinions. I make my polls fun, and generally they relate to mundane things in my life such as 'which goes in first, the milk or the tea'? Or when I am outraged at what someone's got in their basket at the supermarket. But let's be honest – when has a Yes or No poll ever really helped us? It hasn't in politics, and I'm not sure it's always going to be the best compass in your life. Use them for fun, use them sparingly – you already know the answer if it's really important. And to answer your question, the tea goes in first, every.single.time.'

@bettymagazine, UK

TO WRITE IN RAINBOW TEXT IN YOUR STORIES

Type your text and then highlight the words you want to make rainbow-coloured. Hold one finger on the blue line at the end of your highlighted text, then use your other hand to hit the purple colour option and hold. This opens up the whole colour chart. Keeping both fingers in contact with the screen, gradually swipe left, moving your lower finger across the colour chart and your upper finger along your text selection. It can take a few tries to get the hang of it, but the result is pretty, eye-catching and immensely satisfying when you do!

If you're more of a visual learner, check out my video tutorial for this along with my templates for Stories at **meandorla.co.uk/hashtagauthenticbook**

assume that only your loyal following will get to actually see it and you have the chance to record and delete as many times as you like before sharing.

Some tips from the pros on talking to camera: look at the camera lens, not your own face; plan what you're going to say and how you will end the message; and do a few takes to get it right. Make use of flattering face filters (can we get these for real life too, please?) to ease you in to having your face on-screen, and use a subtitle or caption to help users know what you're talking about.

Check out my 'talk to camera' challenge at meandorla. co.uk/hashtagauthenticbook for monthly prompts and tips to get you chatting with your audience more.

INSTAGRAM LIVE

Instagram Live offers you the chance to 'live broadcast' yourself to both your existing followers and across the wider app. As terrifying as it sounds,

it's actually surprisingly fun, with most who give it a go enjoying it more than expected! Live broadcasts are a great way to answer questions, show people around, teach or run a tutorial or simply chat with your audience in real time. You can choose to go Live with a friend, via the split screen option, which can make it slightly less intimidating and give you somebody to bounce off.

If you're nervous to begin with, consider setting your profile to private before going Live, then opening it up to public again once you're done. That way, only your followers can see, and you won't be promoted to strangers via Instagram's promotional pages, which is where the trolls sometimes sneak in from.

Some users report an influx of spam or abusive comments during Live broadcasts, so check out my pointers on safety (see pages 187–189) for ways to protect yourself from this.

Ten ideas for interesting Instagram Stories

1. **Be human.** The most popular Stories are raw, real and relatable – whether it's sharing your work or domestic disasters, or simply speaking in a candid and open way.

2. **Share little doses of wisdom.** These could be daily recipes (people can screenshot to save), tips, uplifting quotes, parenting prompts or ways to make social change. You can make and save these in advance to help build consistency.

3. **Share a problem you're experiencing, big or small.** Ask people to offer their suggestions.

4. **Bring your audience along with you to an event or trip.** Try to piece the clips together to form a narrative, with a beginning, middle and end.

5. **Give a short review of something.** Share what you're reading/watching on Netflix/talk about the facemask you're wearing/tea you're drinking. (Tag the brand for a chance they'll notice and repost your stories to their audience, too!)

6. **Livestream yourself reading your latest blog post**. You can then answer questions about the topic.

7. **Host a live coffee morning**. Using the invite-a-friend feature, share the screen and chat face to face with your audience.

8. **Reinforce your main content.** Whatever your mainstay content is, share more informal everyday versions of this. My main gallery is about the little moments of magic – so I might share my kettle boiling, a rainbow on the moors, the lovely handwriting on a letter that's just been delivered.

9. **Show behind the scenes** – of your work, your routine, your business or your life.

10. **Share other content you're loving on Instagram.** Use the paper aeroplane symbol under any post (including your own) to share it in an Instagram Story.

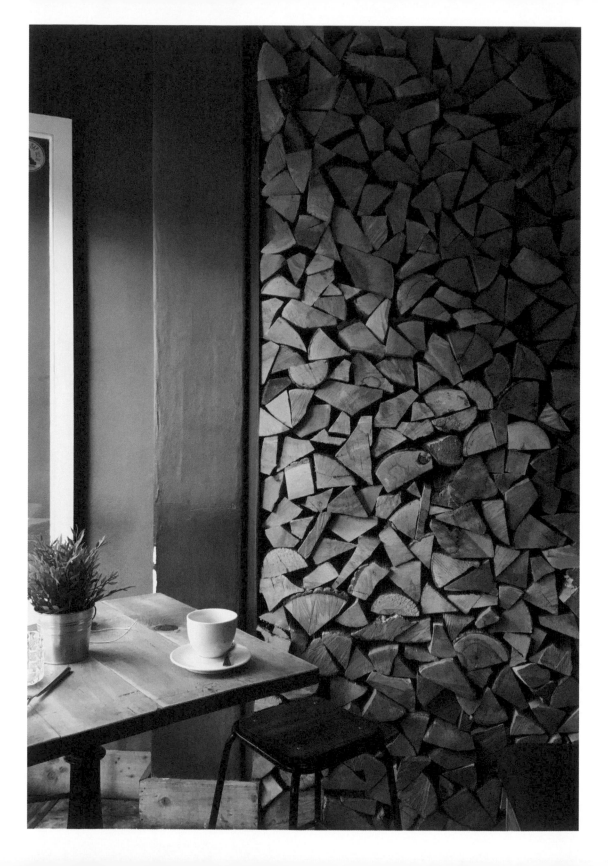

SUCCESS ON YOUR OWN TERMS

The trees that are slow to grow bear the best fruit.

Molière

So you're nailing your content – now, how do you grow your audience? With social media offering us all the temptation to track our popularity in tangible stats, it can feel like the most important question of them all. In reality, it's more nuanced: yes, most of us would like an audience, but it doesn't need to be huge in order to start making things happen.

One great thing about posting your work online is the ability to get immediate feedback on what you share. It's kind of like putting everything out for scoring by the world at large – which can be both wonderful, and a little overwhelming. For this reason I urge you not to get hung up on the numbers.

Instagram, like any platform using algorithms to arrange and order its content to viewers, does not necessarily prioritize the very best photography. As a commercial enterprise, its interest is always going to be in promoting the content that gets the most response – be that shares, time spent watching, likes or comments. It's important that we measure our work's success on our own terms.

LIKES AND COMMENTS

Each time you post an image you'll collect these two basic numbers – how many times it was liked and how many comments it received. Most people tend to judge their work by how many likes it attracts, which in my view makes surprisingly little sense.

What means more when you give it as a viewer – a like or a comment? Which is more throwaway, and which is the deeper response? If you're looking to build relationships, establish an engaged and loyal community around you and get real, meaningful interaction with your audience, comments are the metric to really invest yourself in. Sure, it looks less flashy on the imaginary leader board of like-counts – but when it comes to converting an audience into something more, comments are worth infinitely more than the likes. As long as your comment count is gradually increasing, you can trust that you're on the right track.

FOLLOWERS (AND UNFOLLOWERS)

The other big number people get stuck upon is their follower count. It's easy to see why: since the early days of MySpace and Facebook, people have been judging their popularity – and that of others – by how many friends or followers they have. But this isn't Pokemon and we don't need to 'catch 'em all'. A small, engaged community can be twice as valuable and powerful as a larger, more generic one.

YOUR RIGHT PEOPLE

If you're looking to grow a big following, the most important thing to ask yourself is why, and what do you plan to do once you have. Do you make

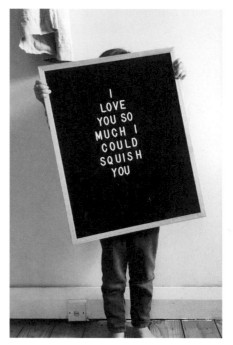

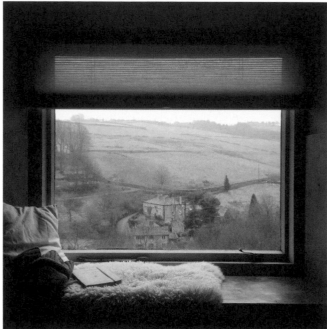

things and want to sell enough to quit your day job? Are you hoping to become an influencer, or publicize your blog? Or do you simply want to make connections and talk to like-minded people around the world?

You might be tempted to think, 'I don't care who my followers are, I just need a bigger number.' So, here's my analogy.

Imagine you make French indie films that are raved about by the critics. Arty, beautiful, black and white. You decide you want wider recognition and come up with a plan to get a TV exec to start broadcasting your movie mid-way through one of those prime-time super-popular TV talent shows to an audience of millions. The show stops: your movie begins. What happens next?

Realistically, about 98 per cent of those viewers are going to squint, watch for a minute, and then switch to another channel. It's not that there's anything wrong with your arty French movies. It's just that they're not for everyone.

It is the same with our followers online. If you were gifted 100k new Instagram followers tomorrow, you'd see huge swathes of them disappear with every post. Not everyone is there to see the kind of work we create and not everyone will get it or be our 'right' kind of people. And that's totally, freeingly fine.

Don't take any unfollows to heart. Anyone who doesn't like or get our work is not someone we should want to keep around. I see it as a little like panning for gold: you scoop in the dirt, give it a shake. We're only interested in collecting those glittering nuggets of golden brilliance. Everything else is just noise, and is welcome to fall through the cracks.

'My relationship with Instagram has changed recently. I realized that I was missing a lot of friends' and family updates because I was following over 500 people and it was hard to scroll through it all! So I decided to split my accounts. Now I have a professional account for work (32k followers) and a personal one (with only 80!). It means I can post pictures of my nieces and nephews without worrying that I'm sharing them to thousands of people against their will, and it allows me to never miss a family or close friend's post. I love my professional account too: discovering new people, supporting those in my industry and sharing my book/podcast/events. It's the same way I used to use my blog (short-form life updates) and Pinterest (for inspiration and motivation). I set my bigger account up as a "business account" so people can find my email address and contact me. Instagram is part of my business and a small part of how I make my money. I like that the two accounts have clear parameters. I'm not saying it's *the* way to use IG, but it's a way that works for me.'

@emmagannonuk

FINDING YOUR PEOPLE

I've been on Instagram for the past five years or so and yet the wonderful community still surprises me every single day. When I recently shared a very personal health story I was flooded with so much love and support – it moved me to tears. Instagram truly makes me believe in the kindness of strangers.

@busraqadir, Germany

So, how do we find more of those arty French cinema types – or whoever we need? The first step is to think about who our right audience is – and handily, we have a pretty good guide to this close at hand. Generally speaking, our right people are an awful lot like ourselves: they like the same things, laugh at the same jokes, shop in the same stores and have similar values. They're the people we'd be friends with, if we met in real life. So a good place to start is to pay attention to ourselves.

How do we discover new posts or accounts? What keywords or hashtags are we searching under? What locations or stores are we tagging in our posts? Then we can reverse engineer this, and have our content show up in these corners of the app.

HASHTAGS

Hashtags are a way of indexing a post, assigning it categories under which others can then search for it. As the sheer volume of content online has increased, visibility under hashtags has become less of a guaranteed win, but they are still worth using and browsing regularly yourself.

Instagram allows up to thirty hashtags per post, but I recommend using around ten, and choosing a mixture of very active and some less popular tags

to increase your odds of discovery. Put them in your caption or in a comment below – it doesn't make any difference – and be sure to use different tags to suit each image and topic that you share.

Look out for hashtag challenges, contests and feature accounts, such as the 'weekend hashtag project' or #whp (see page 106), which offers a chance to be featured to an audience of millions.

I share fresh, seasonal and topical tags from the community in my monthly hashtag newsletter, which you can grab at meandorla.co.uk/hashtagauthenticbook.

EXPLORE

Explore is the page under the magnifying glass icon in the app – a grid showing an algorithm selection of posts that the system expects you will like. Hitting Explore is a great way to get discovered and to grow. Posts make Explore based on a complex variety of factors, but a post that attracts lots of likes, shares and comments in the first thirty minutes is far more likely to be featured this way.

SUGGESTED ACCOUNTS

Tap the downward arrow beside the user name on anybody's profile page and you'll see a list

of similar 'suggested accounts'. Anyone newly following an account is automatically shown this list, and being in one of the first few spaces on the slider is a great source of new eyes and followers to your page. You can test this for yourself, too, by logging into a second account and seeing who the algorithm is suggesting as similar to you.

The precise metrics of how these connections are calculated are a closely guarded secret, but it's likely to include people you often exchange comments with, are connected with on Facebook or via direct message, those who have @-mentioned your user name in their own posts or Stories, and people appealing to lots of the same people as you.

ALGORITHMS

Anyone familiar with Instagram has heard the grumbling about algorithms. Introduced in 2016

to rearrange users' timelines, their official intention is to show everyone the most interesting and relevant content from the people they follow. Many people feel that these changes have impacted on the visibility of their posts, and report reduced engagement, reach and growth as a result – and I can totally sympathize. Algorithms are, by nature, flawed and overly simplistic, and in a community as intimate as Instagram, having a digital system disrupt all that human connection feels jarring and wrong. If you worked hard to build something up and saw a drop in your reach, of course that's upsetting, and feels scary to boot.

It's been a few years now, though, and I've reached an unpopular conclusion: it's time to stop blaming the algorithm. This is the reality of social media today. It is our job as creators to craft content that can flourish within that algorithmic

eco-system, or to take our energy and invest it elsewhere. I have helped thousands of creatives grow their accounts in a post-algorithm Instagram, so I promise it is still possible. The trick is to stay flexible and follow our passion, and then we can out-create any change the system may throw at us.

So, you've found a community of like-minded souls. How do you convert them into followers? The answer is simple – do as you would in an offline social situation, and start to gradually get involved in the group.

If great content is the doorkey, then engagement is the porch light to building a community online. Authentically commenting, liking and connecting shines a light on our work, and lets people find us in an organic way.

Share little and often. I like to squeeze in engagement time regularly throughout the day – when waiting for the kettle to boil, when standing in line at the bank. Five minutes here and there can add up to a whole lot of cheerleading for the others in your community, and bring a lot of love back to you.

Reply to comments and DMs as much as possible. Not only is replying the polite and kind thing to do, but it also reminds the other user you exist and helps to build a relationship – both emotionally, and in the churning algorithm databanks of the app!

Return the favour. Likewise, if folks are regularly taking the time to engage with your posts, it's only polite to mirror the kindness and visit their page in return. You don't have to follow everyone who follows you, but visiting their page, keeping up with their life and leaving comments in return lets people know they are appreciated.

Make it meaningful. Short comments like 'nice pic' or 'so sweet' are unlikely to generate much response, or build great relationships. Overall, it's better to leave fewer comments but make the ones you do count – considered, personal and genuine.

Get out of your bubble. One major downside to algorithms is they have a tendency to keep showing us more of what we've already liked. Get out of your bubble by throwing some wildcard search terms into the app, and checking out accounts from the other side of the world. Google-translating popular search terms or hashtags can be incredibly eye-opening – I've found so many incredible Japanese fashion stores and photographers this way!

Make it timely. When posting to Instagram, make time to be online immediately afterwards to engage and reply. As we know, the first thirty minutes or so are a crucial window for engagement and reach, so it pays to be there to interact and bring awareness back to your page.

Don't overdo it. A liking spree is all well and good, but leave too many too fast and you'll find yourself locked out from engaging for an hour or so. Likewise, leaving too many short comments, or too many with similar words can trigger a spam warning and temporarily lock your account. Most users find that they never reach these limits, but it's another reason to steer well clear of any dodgy automated software that promises to like or comment on your behalf.

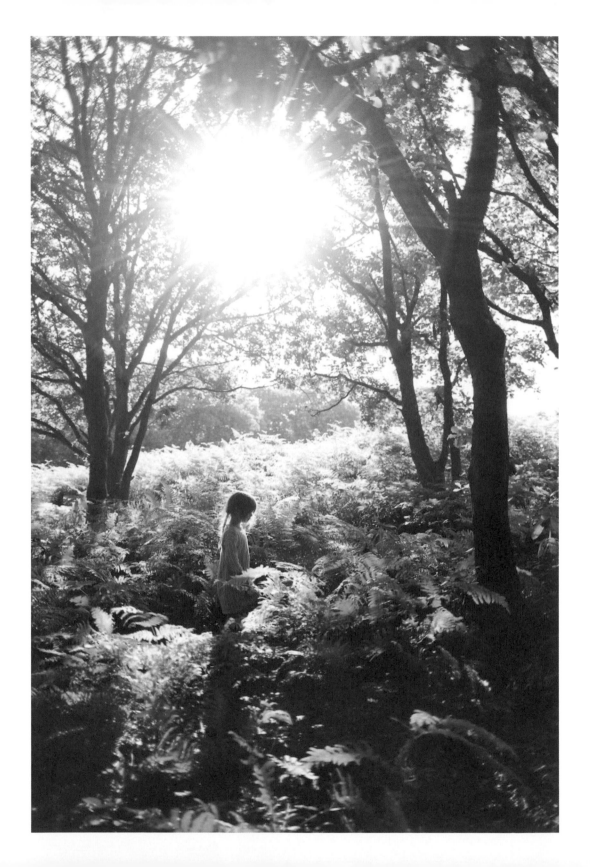

SUCCESS BEYOND INSTAGRAM

Instagram is the best tool to express my inner mind.
I can share the latest expressions of what I have cultivated so far with people
around the world. It's a motivation to make new things towards the future.

@errer_, Japan

An audience on Instagram is a wonderful thing – a community in your pocket that you can turn to any time or place. But ultimately it is a step to something bigger, and not the destination in itself. It's easy to see people with large followings online and think they have 'made it'; that if you could only match that audience size your life would fall into perfect order. It doesn't and it won't. However perfectly styled their house might be; however little TV their kids may watch; however much sunrise yoga they seem to squeeze into their day – that following makes no difference to how they think, feel and sleep.

That's not to say Instagram can't open doors, but knowing your big picture goals is a crucial step, and allows you to see much more clearly what really matters for you.

We're so used to success being defined by our bank accounts and how hard we work, but the growing world of online entrepreneurs allows us to draw new and different lines. Success for one person might be heaps of cash, but for another it is more time with their children as they grow, or the freedom to work a three-day week and still pay the bills. Personally, I have a chronic health condition, and being able to work from home (and from bed, when needed) was the biggest goal I had in mind when I started out.

Crucial to making these things happen is translating those Instagram friends and all the lessons you've learned into the next step of your greater hopes and plans.

YOU NEED A MAILING LIST

Direct emails remain the best way to make meaningful contact with your whole audience. Should social media platforms dissolve tomorrow, a mailing list means you can maintain those connections.

It's easy to get started for free on providers like Mailchimp, and add a simple form to your website or Instagram profile URL to begin collecting people's email addresses. (Make sure you're explaining clearly what you'll use those email addresses for and to comply with data protection regulations and rules.)

IMPROVING CLICK-THROUGH

How can we get our audience to move from Instagram over to our website? With only a single link on our profile page, we need to put it to work. Just updated your shop? Tell people about it! Written a new blog post? Make sure your audience knows. That sounds obvious but so many of us shy away from self-promotion fearing we'll alienate our audience or seem self-absorbed. The truth is, when we create something wonderful, our audience want to find out.

Most blogging platforms offer the option to create 'pretty' URLs – ones with a readable title, instead of simply a random string of letters and characters. These offer a preview as to what to expect behind a profile link, and they tend to garner more interest.

Links in Stories generate brilliant click-through, but are currently limited to only those Verified and Business accounts with more than 10,000 followers. With or without the feature, make use of Stories to preview your off-Instagram content, sharing screenshots, excerpts and teasers to let people know what they'll be missing if they don't click over to see.

MAKE IT LAST

A truly invested audience will stay with us for the long term. The artists and bloggers I loved a decade ago I generally still love; their lives have evolved, and so has mine, but their individual voice at the heart of their work has continued to connect with me. Of course there are no ways to guarantee anything in life, but by staying authentic and connected to our passions, we stand the best chance of keeping momentum, interest and relevance in our work, long into the future.

One final tip I'd add to that is – whenever you find yourself tempted to 'cheat'; whenever you start Googling fast growth strategies or think of buying followers or likes: stop, take stock, and pour that energy back into your work. Inflating your numbers by artificial means is a lot like wearing one of those inflatable muscle suits and trying to win the Tour de France. You might look the part to an untrained outsider, might feel better for a while, but in the end it's a disaster and all you're left with is hot air.

The real recipe for success

I know it's tempting to look for quick fixes, and wish for a fast route to success. The truth is, for it to mean anything, it has to come slowly, and bring all the lessons that we pick up along the way. It took about two years for me to build a really meaningful following, and another two years from there to develop a business from that. When most people say that social media isn't working for them, it's simply a question of giving it more time.

If I could distil everything down to a series of tips, it would be those shared below. These are the real secrets to making it work, along with hard work, an open mind and a good dose of tenacity.

1. **Post brilliant content.** That might be your most beautiful photography, your funniest video, your most relatable story – one person's 'brilliant' will look totally different from the next, and it will change over time for us all. It's not about perfection, or impossible standards – it's just being selective and sometimes pushing ourselves.

2. **Engage, engage, engage.** Unless you are Beyoncé (Hi B! Thanks for reading!) then your social media is not simply a broadcast platform; the clue is in the name, and the 'social' part is absolutely essential. Spend more time, daily, exploring other people's pages than you do on your own. Like, comment, share, discuss. It's a little like walking solo into a party and trying to make some new friends – you have to get out of your comfort zone a little, push yourself to be chatty and hang out where your people are.

3. **Be persistently curious.** Try new things, and watch the results. Why didn't people engage with that post? What was it about this one that meant everybody replied to your question? On social media we get to test our market, day after day, and we can use this data to gently shape how we share. I first discovered my audience loved hearing my thoughts on Instagram when I saw a huge spike in blog traffic whenever I posted Insta tips. So, I wrote more of those posts, then a free ebook, which gradually formed my classes, talks and this book. It's that curiosity, that willingness to be surprised that defines the people who make it work.

4. **Accept there's no magic wand.** There are no shortcuts here: only by figuring out who we are and what we really want to share with the world can we build something of value online. As the platforms grow busier and busier and everyone's attention span shrinks, it's the people with a unique voice, a clear and consistent message and a strong sense of self who really stand out and succeed. Trust in the process, keep learning and sharing, and know that there's nothing more valuable than all the knowledge and experience you gain along the way.

SET A TIMER

If you know you're prone to being sucked into social media for longer than intended, setting a timer on your phone is an easy way to snap yourself out of an accidental binge. There are dedicated apps available to help you limit distracting platforms, or ration your time online. How long is acceptable or normal to spend on social media is entirely individual – some find joy in several hours a day, and others do best if they ration it out. The trick is to make it intentional, and not let the hours slip by without your consent.

MAKE USE OF SAFETY FEATURES

Instagram has built-in options to block unwanted followers, offensive language, specific key words and to hide your Stories from anyone you choose. You can also switch your profile to private at any time (and back again), and you can turn comments off on individual posts. Any abuse, inappropriate content or spam can and should be reported using the options provided, so that Instagram can review and remove it. IG has the most friendly and welcoming community I've found online, and generally your followers will support you if anyone tries to lash out. I've only ever had a couple of nasty comments in all my thousands of posts.

CURATE YOUR EXPLORE PAGE

If you're regularly being shown content you find upsetting, distasteful or unhelpful for your mental health, it's easy to tell the app that you don't want to see posts of this kind. Tap on the offending post

and hit the three dots in the top right-hand corner. You'll see an option titled 'show fewer posts like this'. Do this for all the problematic posts, and the algorithm should start making better suggestions.

BE WISE TO PHOTOSHOP

'The camera never lies' is a phrase that isn't ageing well. While the camera might record the truth, the pictures we see are easily altered in Photoshop, or even in phone-based apps. It's not only celebrity idols and models manipulating their image – there's a big trend for fashion bloggers and regular people making use of editing options, often to produce a fake reality that their followers believe. The answer is not going to be found in policing how people creatively process their images but for us, as the audience, to become more clued up on what we are looking at, and how to decipher it.

BE WARY OF UNQUALIFIED PROFESSIONALS

Be wary of trusting your health to a stranger on the Internet. Most have very good intentions, and some are excellent and knowledgeable, but it can be very hard to tell the good from the bad, and neither follower count nor a blue 'Verified' tick can replace a genuine qualification. Do your research, check testimonials, and ask your (offline) doctor if in doubt.

KNOW WHEN YOU'RE BEING SOLD TO

Sitting alongside both of the previous points comes the confusing world of concealed marketing. How do we know when someone is sharing their honest

opinions, and when we're being subjected to a paid promotion? By law, Instagram users are supposed to clearly disclose any such work, with a banner across the top of grid posts and Stories, or at least a hashtag such as #sponsored or #ad. If a user was given a product for free but was not paid to post, they should still be mentioning this in their caption – usually with a phrase like 'gifted' or 'review sample'. However, as the penalties for failing to disclose have so far been rather light, a lot of sponsored content appearing on Instagram still isn't making itself clear. You can often spot a hidden ad by a few common features: packaging is shown deliberately facing the camera, the brand is prominently tagged, and the caption talks in glowing terms about a product. If in doubt, ask the creator if they were paid, and they should be happy to answer you.

UNFOLLOW ACCOUNTS THAT MAKE YOU FEEL BAD

It sounds so obvious, but many of us fail to do this, for fear of offending, losing followers ourselves, or simply for the dark pleasure of looking at something that hurts. Take a moment, right now, to unfollow anyone that reliably makes you feel blue. Perhaps it's because of their impossibly perfect life, or because they're a bit of a 'frenemy', or because you find their work makes you doubt your own self-worth. If unfollowing will cause too much emotional fallout, use the 'mute' feature instead to hide anyone you need a break from seeing. Your headspace and your happiness are valuable resources, and it's important to be intentional about our influences.

Five things to do right now to make your account safer

1. Head into your settings and turn on the 'hide offensive comments' option. You can also add any other keywords you wish to filter out of comments on your posts and Live broadcasts.

2. Turn on two-factor authentication, which will make your account twice as secure, and a lot harder to hack.

3. If you have an email address in your bio, make sure it is different from the one you registered the account with. Scammers regularly use the addresses on people's profile pages to send phishing emails and steal passwords.

4. Make sure the email address (and any phone number) associated with your account is up to date. If you ever get locked out or hacked, you'll need access to these accounts.

5. Via a desktop browser, go to your Instagram settings and take a look at all the third-party apps you have given permission to access your account. Delete any you don't recognize or no longer use regularly.

AVOID THE VALIDATION TRAP

Possibly the biggest danger of all, and the problem most commonly faced, is the trap of seeking validation online. A photo attracts lots of likes and we feel good, and believe our photography is worthy. If our next one receives a more muted response, we fall into a pit of despair, regret the image and believe we are terrible at everything. Sound familiar?

By playing this game we are essentially outsourcing our sense of self-worth to an app that is not built for the task. Instagram – or indeed any social media platform – is not a democratic tool cross-sampling the population and giving back data on image and caption quality. It's hugely skewed – by trends, by algorithms, by time of day, by userbase.

A photo that went viral two years ago can be met with nothing but crickets today. A photo that does well is simply proof that you're creating content that works well within the algorithm and system. If you feel yourself falling into this trap, try to unhook from both the approval and the feelings of rejection. Learn to appreciate your images for yourself, for what they bring to you, and make that your main motivation and priority.

REMEMBER IT ISN'T REAL LIFE

Even the most authentic, behind-the-scenes of Instagrammers are only ever sharing about 1 per cent of their life. Social media shows the edited highlights of our lives, and for most of us, that will mean the more fun and interesting bits. Yes, sometimes we also share the not-so-fun, but even then it is done carefully, with the things we feel able to share. Don't compare your real life to someone else's highlight reel.

KIDS

If you're a parent, carer or guardian, how much to share of your kids is a thorny question. My personal stance is this: any good parent or carer should of course be considering their child's wishes and safety at all times, online and off. If a child is old enough they should, and undoubtedly will have, a say in it (as anyone who's ever tried to corral a reluctant kid in front of a camera lens can tell you). Statistically, there's no evidence to say that children whose images are shared online are at any greater risk of harm by strangers, but of course, we should never take unnecessary risk. A good rule of thumb is 'Would I want to share this picture/story if it was of myself?' Be mindful of sharing any unnecessary personal information like school names, surnames, or locations. And, of course, if you see a post on Instagram that you feel truly puts anyone at risk, always reach out to the original poster and/or report it, as appropriate.

YOUR PERSONAL LIFE

One of the most powerful ways we can connect with others through the barrier of the Internet is to get personal – sharing real, vulnerable and emotive elements of our lives. I have learned this lesson myself a thousand times; that the post I'm most anxious about hitting 'publish' on usually winds up attracting the most wonderful response. How do we balance this against our very real need for privacy and head space? My secret method is this: I never share anything online until I feel completely okay about it in my own mind. Sometimes that means I'll write a caption or blog post in the midst of a crisis, but then I'll sit on it until a time a month or so later when I have enough distance to share it mindfully.

Ten commandments for a healthy
relationship with social media

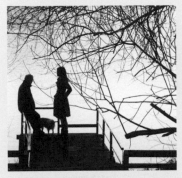 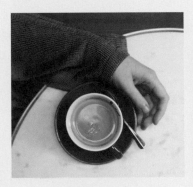

1. **Share, don't brag.**

2. **Spend more time on other people's pages than you do on your own.**

3. **Be human.**

4. **Mix it up.**

5. **Aim to serve others (instead of being self-serving).**

6. **Create what makes you really light up.**

7. **Follow your enthusiasm.**

8. **Stay playful and curious and don't take it too seriously.**

9. **Take responsibility for your own boundaries.**

10. **Don't compare yourself to other people.**

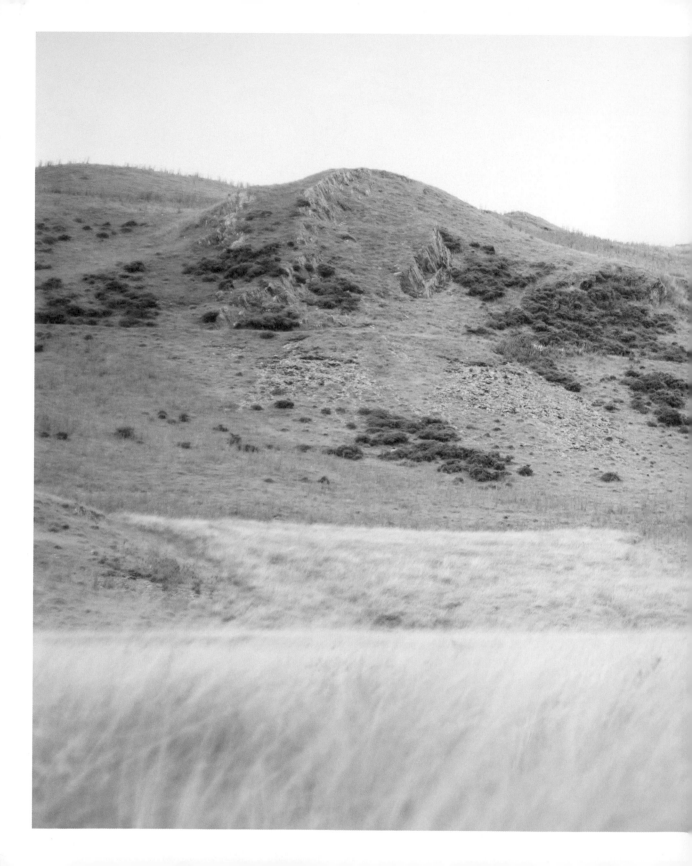